C000058164

OXFORD SUBURBS & VILLAGES

THROUGH TIME

ST GILES, HEADINGTON, ST CLEMENTS, COWLEY, IFFLEY, WYTHAM

Stanley C. Jenkins

AMBERLEY PUBLISHING

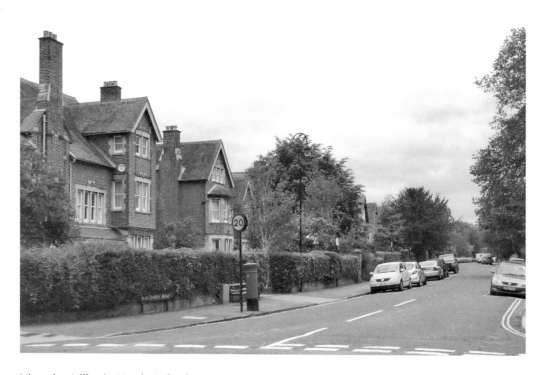

Victorian Villas in North Oxford
An archetypal North Oxford scene, showing a row of Victorian villas at the west end of Rawlinson Road. These relatively large houses were designed and built for upper middle-class occupants.

First published 2013

Amberley Publishing
The Hill, Stroud, Gloucestershire, GL5 4EP
www.amberley-books.com

Copyright © Stanley C. Jenkins, 2013

The right of Stanley C. Jenkins to be identified as the
Author of this work has been asserted in accordance with
the Copyrights, Designs and Patents Act 1988.

ISBN 978 1 4456 1287 4 (print)
ISBN 978 1 4456 1308 6 (ebook)

All rights reserved. No part of this book may be reprinted
or reproduced or utilised in any form or by any electronic,
mechanical or other means, now known or hereafter
invented, including photocopying and recording, or in
any information storage or retrieval system, without the
permission in writing from the Publishers.

British Library Cataloguing in Publication Data.
A catalogue record for this book is available from the
British Library.

Typesetting by Amberley Publishing.
Printed in Great Britain.

Introduction

Oxford originated in the early tenth century as one of the fortified 'burghs' constructed by King Alfred and his descendants during the Viking wars. The new town, which was built on the site of a small, pre-existing settlement, was protected by an encircling wall, which would later delineate the limits of the city centre.

The Domesday Book reveals that the first suburbs had appeared beyond the wall by 1086, when Oxford contained 'as well within the wall as without ... 243 houses which pay geld, and besides these there are 500 houses less 22 so wasted and destroyed that they cannot pay geld'. St Clements was the most important of these early suburbs; it was situated just outside the South Gate, and was in existence by the eleventh century. Archaeological evidence suggests that there may have been similar Anglo-Saxon suburbs beyond the North and West Gates; the area in front of the North Gate known as St Giles had certainly appeared by the twelfth century.

Urban expansion took place steadily throughout the medieval period and by 1801, Oxford had a population of 11,694. Thereafter, the city's population began to expand more rapidly, rising to 23,834 in 1841 and 37,057 by 1901 – much of this growth having taken place in new suburbs that had appeared well beyond the confines of the original urban centre.

The upper sections of the middle class had, for many years, been keen to emulate the lifestyle of the country gentry, and these aspirations became much more pronounced as the industrial revolution got fully into its stride. Successful traders and professional people started to migrate towards the outskirts of the city in considerable numbers; by the 1850s, for example, there were said to be twenty-three 'gentlemen's houses' in the village of Iffley.

The individuals who resided in these country retreats had no intention of creating new suburbs, but as the demand for out-of-town properties increased, powerful landowners such as the Oxford colleges began to plan ambitious residential developments as a means of increasing the value of their land. St John's College, in particular, was instrumental in laying out the Norham Gardens Estate and other areas of North Oxford, which became classic upper middle-class suburbs.

In addition to these prosperous middle-class residential areas, North Oxford contained several working-class enclaves, notably the district of high-density terraced housing known as 'Jericho', and the much later suburban developments in and around Summertown.

Meanwhile, suburban encroachment was taking place elsewhere in the Oxford area, notably around Headington and Cowley. However, the period of greatest expansion in south and east Oxford occurred during the twentieth century, following the establishment of the Morris Motors Works and the neighbouring Pressed Steel factory; the two plants employed around 7,000 people by the mid-1930s, rising to 20,000 in the 1970s.

The growth of the city was accompanied by various boundary changes as the new suburbs and former rural villages were absorbed; St Clements parish, for example, was incorporated into the City of Oxford in 1835 under the provisions of the Municipal Corporations Act, while Headington, Cowley and Iffley were swallowed up during the twentieth century. Meanwhile, a similar process was taking place to the west of Oxford, where several parishes and districts that had formerly belonged to Berkshire were absorbed into the city.

The following chapters are arranged on a geographical basis, Chapter One being a relatively detailed study of the purpose-built Victorian suburbs of North Oxford, while Chapter Two

covers the 'absorbed' villages of Headington and Marston. Chapter Three examines St Clements, Cowley Road, Iffley Road and Cowley, and the final chapter looks at a number of villages on the east and west sides of the city.

Some of these Oxford villages, including Iffley, Kennington, Hinksey and Wolvercote, have been joined to Oxford by ribbon development and have in this way been absorbed into the urban area, although Iffley and Wolvercote have nevertheless retained the character of historic villages. Beckley, Cumnor, Forest Hill, Godstow, Horspath, Wytham and Woodeaton, on the other hand, are still surrounded by open countryside, and have remained more or less rural in character.

Acknowledgements

Thanks are due to the Soldiers of Oxfordshire Trust for the supply of photographs on pages 48, 62, 63, 64, 65 and 66. Other images were obtained from the Witney & District Museum, and from the author's own collection.

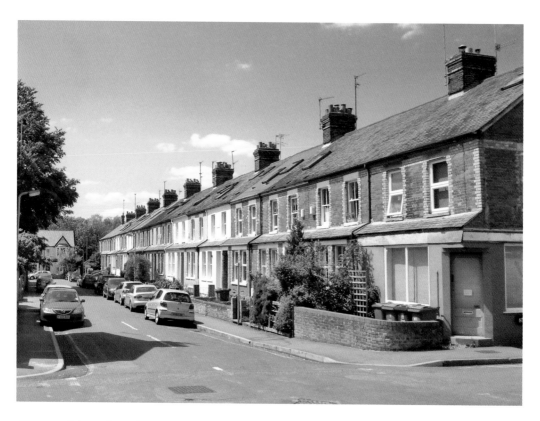

Above and Opposite: **Victorian Houses in South Oxford**
Terraced houses such as these examples in Chester Street would have appealed to members of the lower middle class, such as bank clerks, shopkeepers and small tradesmen.

CHAPTER 1

North Oxford

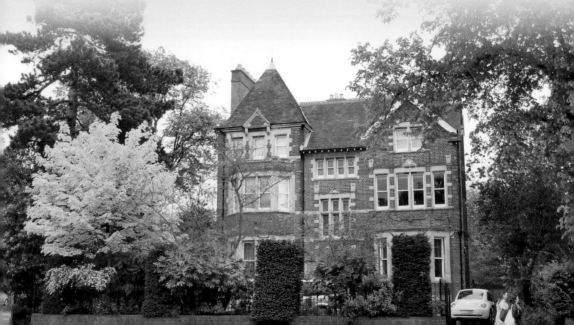

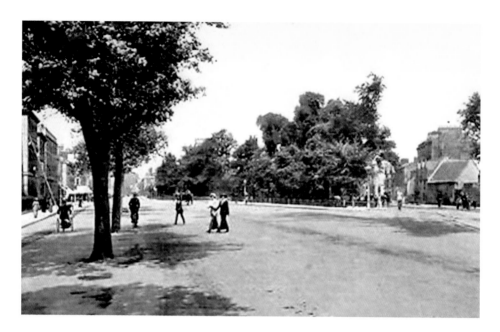

St Giles

Situated immediately to the north of the city wall, St Giles was one of Oxford's first 'suburbs'. The upper view, from a colour-tinted Edwardian postcard, shows the north end of St Giles, looking northwards along the Woodstock Road, with Banbury Road visible on the extreme right. The lower view is looking along the Woodstock Road from a similar position in May 2013; the embattled tower of St Giles' parish church can be seen to the right of the picture.

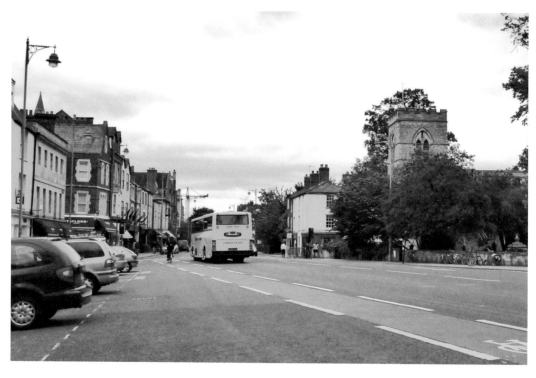

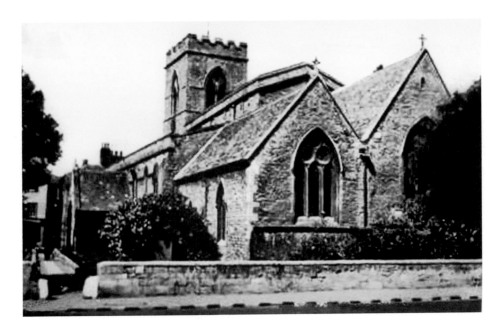

St Giles' Church

Nestling in the 'V' of the diverging Woodstock and Banbury roads, St Giles' church retains much of the atmosphere of a rural church, which it once was. The building, which consists of a nave, aisles, chancel, west tower and south porch, dates mainly from the thirteenth century, although blocked Norman windows can be seen in the nave. The sepia view shows the church from the east, possibly during the 1940s, while the colour photograph was taken from the south-west in May 2013.

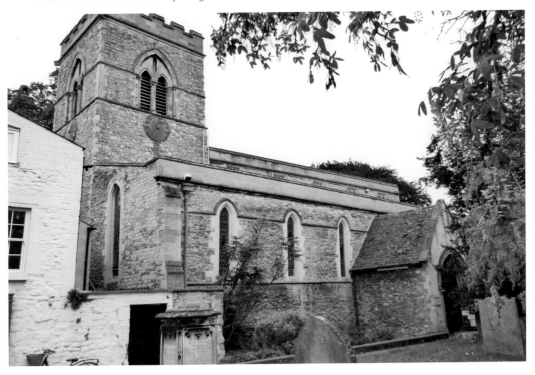

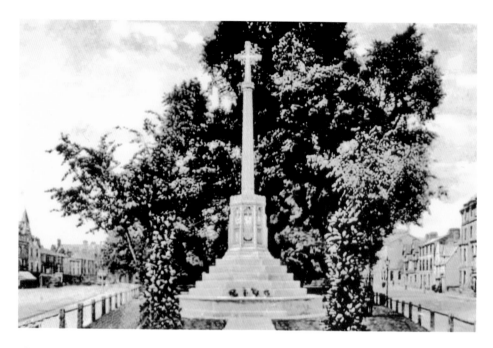

The War Memorial

Standing on a prominent site near St Giles' church, Oxford's war memorial was unveiled in 1921. It is in the form of a fifteenth-century cross upon an octagonal pedestal, and was designed by Thomas Rayson (1888–1976), in association with John Thorpe and Gilbert Gardner. Rayson, who had been involved with the construction of Witney Aerodrome during the Great War, designed similar memorial crosses at Witney, Woodstock and Chester. The accompanying photographs show the memorial during the 1920s, and in 2013.

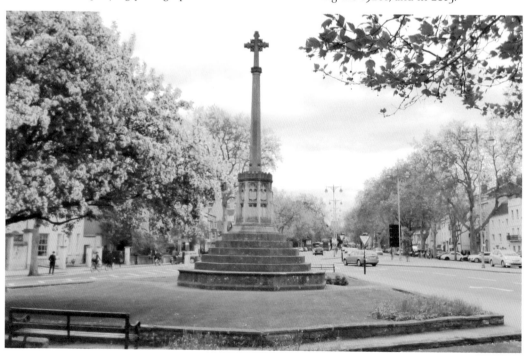

The Woodstock Road & Banbury Roads

These two roads, which extend northwards from St Giles for a distance of over 2 miles, are synonymous with North Oxford. They are linked by a network of inter-connecting roads which follow an approximate east-to-west alignment, thereby creating an informal 'grid' pattern – although the resulting layout is by no means as regular as that found in many American cities. The upper view shows an electro-diesel bus in Banbury Road, while the lower picture shows typical North Oxford houses in the Woodstock Road.

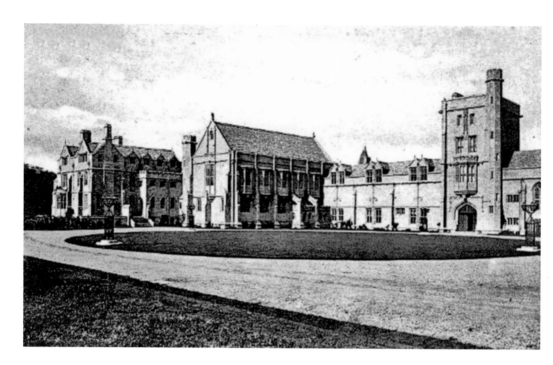

Mansfield College

Several of Oxford's younger colleges are situated in the North Oxford area, one of these being Mansfield College, which is sited in Mansfield Road, to the east of St Giles. This college originated in Birmingham as a Nonconformist training college, but it moved to Oxford in 1886. The buildings, designed by Basil Champneys (1842–1935), are in traditional medieval style, as shown in the accompanying photographs; the sepia view is an old postcard, while the colour photograph was taken in 2013.

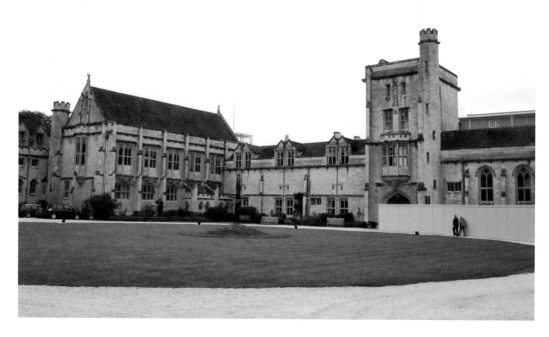

Somerville College

Women were first admitted to Oxford in the 1870s, but they were not allowed to become members of the university until 1920. Lady Margaret Hall and Somerville, the first ladies' colleges, were founded in 1879 as hostels for Anglican and Nonconformist students respectively, but they both became full colleges in 1960. Men were first admitted as undergraduates in 1994. The sepia postcard view is looking westwards across the middle quadrangle (now known as the 'Traffic Quad'), while the recent photograph shows the college entrance.

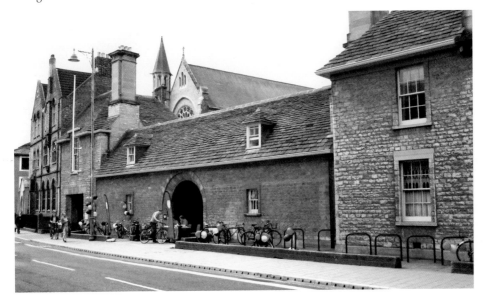

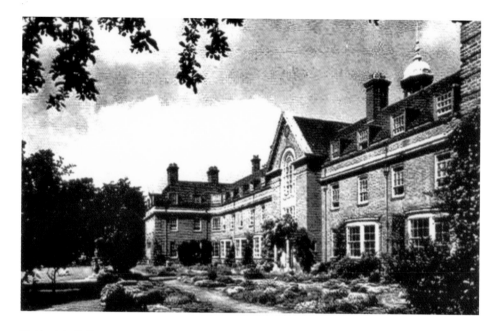

St Hugh's College

Founded in 1886 by Elizabeth Wordsworth (1840–1932), the first principal of Lady Margaret Hall, St Hugh's College, in St Margarets Road, was intended to cater for clergymen's daughters and others who could not afford the fees at the other ladies' colleges; male students were first admitted in 1986. The college boasts some surprisingly grand buildings in the Queen Anne' style, as shown in this *c.* 1950s sepia postcard view, and in a recent photograph of the main entrance, which was taken in 2013.

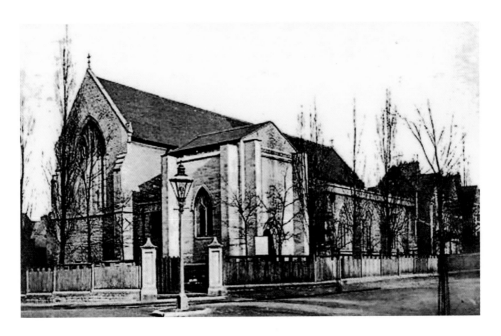

St Margaret's Church

Situated in St Margaret's Road, St Margaret's church was designed by Harry Drinkwater (1844–95). The foundation stone was laid on 8 May 1883 but construction was a protracted business, and although plans for a tower-porch were drawn up by George Frederick Bodley (1827–1907), the tower was never completed. The church was, at first, a chapel of ease within the parish of St Philip and St James, but it became a separate parish in 1896. The upper view is from *c.* 1912, while the lower photograph was taken in 2012.

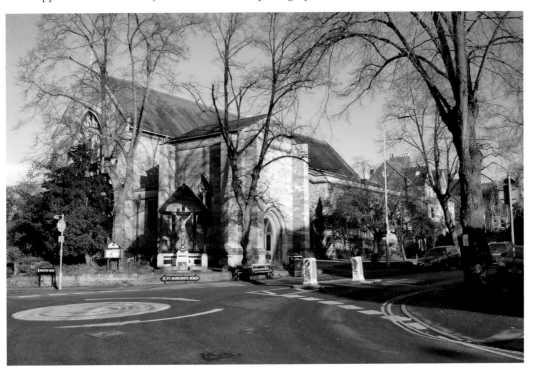

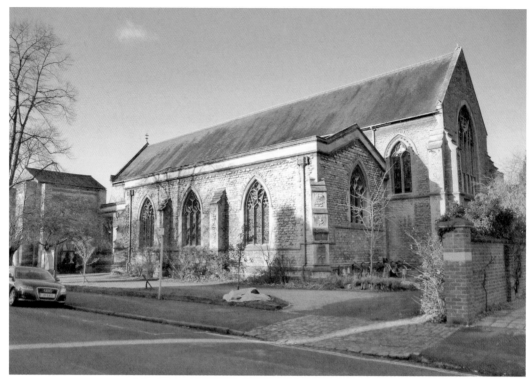

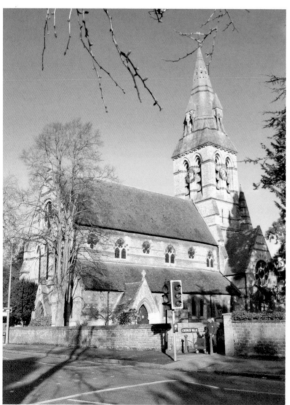

The Church of St Philip & St James

The upper view provides a further glimpse of St Margaret's church in December 2012; the unfinished tower can be seen on the extreme left. If completed, the tower would have been 88 feet high. The lower photograph depicts the neighbouring church of St Philip & St James in Woodstock Road. Designed by George Edmund Street (1824–81), the diocesan architect, this impressive building was intended to serve as the parish church for the inhabitants of rapidly-expanding North Oxford. The foundation stone was laid on 1 May 1860 and this substantially-built Victorian church was consecrated by the Bishop of Oxford on 8 May 1862.

The parish of St Philip & St James was reunited with the parish of St Margaret in 1976, and the church of St Philip & St James was finally declared redundant in April 1982. It is now the home of the Oxford Centre for Mission Studies.

St Barnabas Church

The suburb of Jericho is an area of closely-spaced Victorian terraced houses that once housed manual workers employed in local businesses such as the Oxford University Press and the Eagle Ironworks. It is situated between Walton Street and the Oxford Canal, and is thought to have derived its name from a long-established inn known as the Jericho House. St Barnabas church was built to serve this populous community. Designed by Sir Arthur Blomfield (1829–99), this remarkable Victorian church was consecrated by the Bishop of Oxford on 19 October 1869. The building is constructed of cement-rendered rubble walling, the overall effect being, in many ways, reminiscent of the late Roman or Byzantine style. The upper view shows the church from Cardigan Street, while the lower photograph was taken from Nelson Street in 2012.

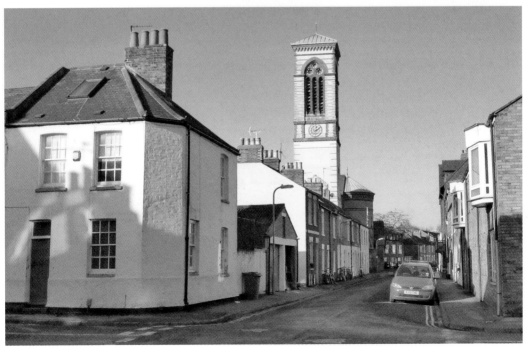

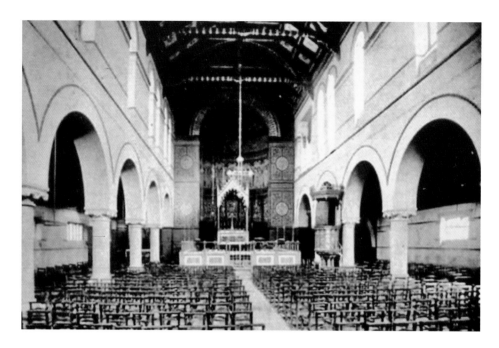

St Barnabas Church

Above: An interior view of the church, possibly dating from the late Victorian period, before the application of coloured decoration on the north wall of the nave. *Below*: This recent photograph, taken in December 2012, shows the cement-rendered exterior walls of the church, which are enlivened by horizontal bands of brickwork. The lofty campanile-type tower originally sported a pyramidal roof cap, but this was removed in 1965, and in its present, slightly truncated form, the tower has a height of 115 feet. *Inset*: The mural panels on the north wall, which illustrate the *Te Deum*, were completed around 1911.

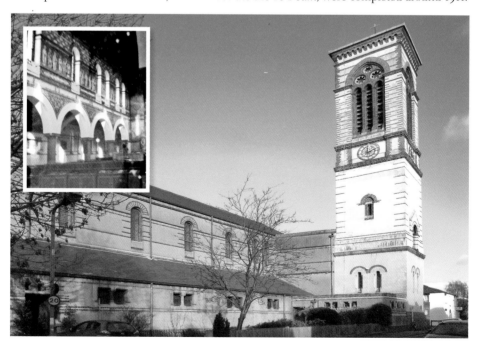

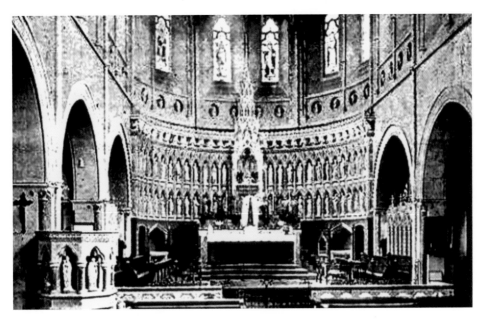

St Aloysius Church

This Roman Catholic church was designed by Joseph Aloysius Hansom (1803–82), the designer of the Hansom cab, and consecrated in 1875. It is constructed of yellow brick, and incorporates a nave, aisles, an apsidal chancel and several side chapels. The church is associated with the Jesuit poet Gerald Manley Hopkins (1844–89), who served as curate here for a period of ten months in 1878.

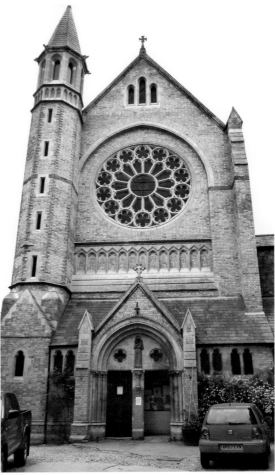

The upper view shows the interior of the church around 1912, while the colour photograph was taken in 2013. The church is dedicated to Aloysius Gonzaga (1568–91), an Italian nobleman who became a Jesuit, and died of fever while attending to the sick during an outbreak of the plague. The unusual reredos, which can be seen in the interior view and was completed in 1887, has sixty-two statues, the upper tier representing English saints and martyrs, while the lower tier represents the rest of the Catholic Church.

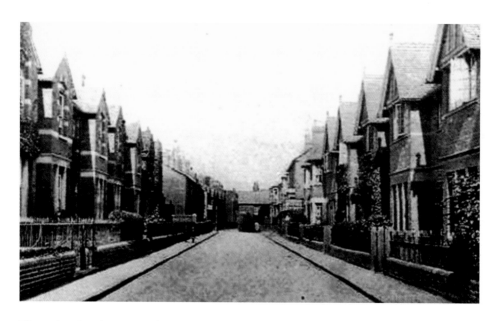

Plantation Road: West End

Running from east to west between Woodstock Road and Kingston Road, Plantation Road was laid out in the 1830s on the alignment of two earlier country lanes. The upper view shows the western end of the road around 1912, while the colour photograph, taken in December 2012, shows No. 39, The Gardener's Arms public house, which is situated in the middle part of the road at the junction of Leckford Place and St Bernard's Road.

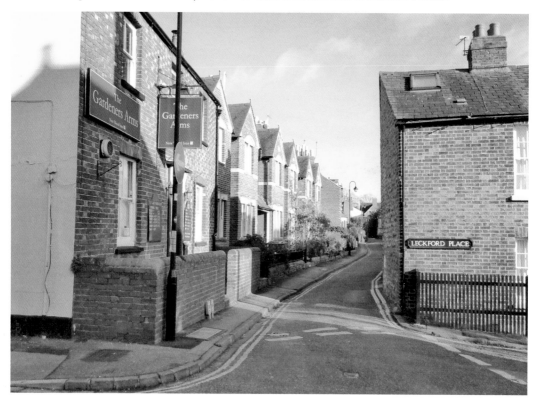

Plantation Road: East End

As its name implies, Plantation Road once gave access to an area of land used as nursery gardens, and the road retains much of its rural character. The upper view is looking east along the narrowest part of the road, the Cotswold-stone building visible to the right being a former bakery. The lower photograph is looking in the opposite direction from a position slightly further to the east; the brick house to the left of the picture is No. 30 Plantation Road, which adjoins the old bakery.

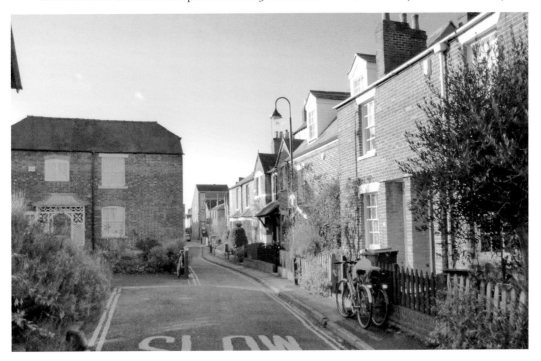

Portland Road

Portland Road, which extends eastwards from the Banbury Road, was laid out during the early years of the twentieth century as part of an urban development scheme that was being promoted by Francis Twining (1848–1929), a local businessman who later became Mayor of Oxford. Gothic architecture was no longer fashionable during the Edwardian period, and the houses in Portland Road reflect the 'vernacular revival' style, with bay windows and 'Tudor' gables, as shown in the accompanying illustrations.

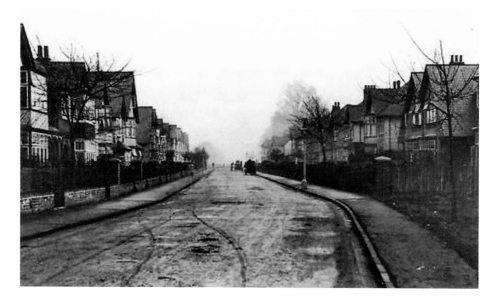

Junction of Woodstock Road & Davenant Road

The upper picture shows the north end of Woodstock Road, *c.* 1912, the country lane leading off to the right being Davenant Road. The lower view, taken from a similar vantage point just over a century later, reveals that the scene has now been totally transformed, many more houses having appeared, while the flow of traffic on the busy Woodstock Road is incessant. The road has been widened and partially straightened, but the raised footpath that can be seen to the left in the earlier picture is still in place.

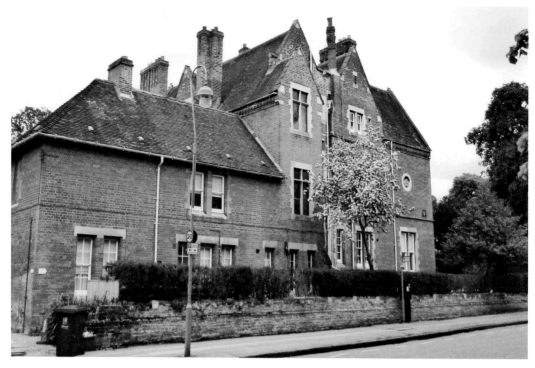

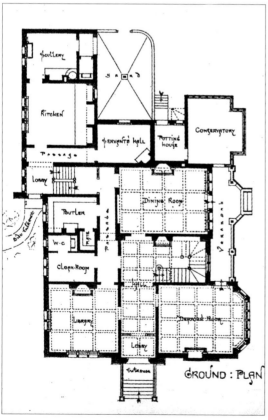

GROUND : PLAN

William Wilkinson & The Norham Manor Estate

Laid out by the Witney architect William Wilkinson (1819–1901) on land owned by St John's College, the Norham Manor Estate was built in the 1860s as a residential suburb for wealthy tradesmen and professional people. Wilkinson designed several of the villas himself, while in his role as superintending architect he was able to ensure uniform standards throughout the new estate. Most of the houses were of red or yellow brick construction with prominent stone dressings.

Wilkinson subsequently published a book entitled *English Country Houses* containing plans and drawings of recently-erected domestic properties, one of these being No. 13 Norham Gardens, a 'show-piece' villa on the Norham Manor Estate, which is shown above. The accompanying ground plan reveals that, in addition to the dining room, conservatory and lobby, the accommodation included a library and servants' hall, the implication being that a house of this size would require perhaps half a dozen servants.

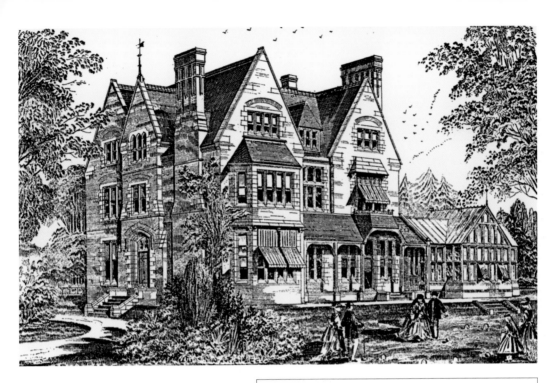

No. 13 Norham Gardens

This illustration from *English Country Houses* shows No. 13 Norham Gardens from the south-west – the drawing room, dining room and conservatory faced south to ensure maximum sunlight. On 16 October 1869, *Jackson's Oxford Journal* reported that this residence, which was being built for Thomas Dallin MA, a Fellow of Queen's College, was 'the largest on the estate', and the work 'was being carried out in a very substantial manner, with red brick faced with light-coloured stone'.

No. 13 later became the home of Canadian physician William Osler (1849–1919), a Fellow of Christ Church and Regius Professor of Medicine at Oxford, and his American wife, Grace Renée. The Oslers enlarged the house and altered its appearance; the 1911 census reveals that they had five live-in servants, including a butler, cook and maids. The lower view is a first-floor plan of No. 13 as originally constructed; note that separate stairs were provided for the servants.

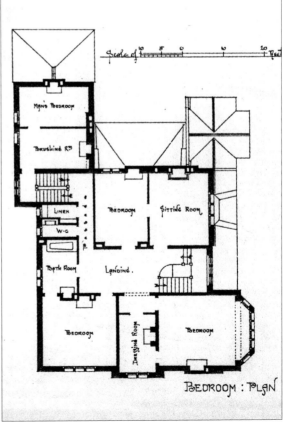

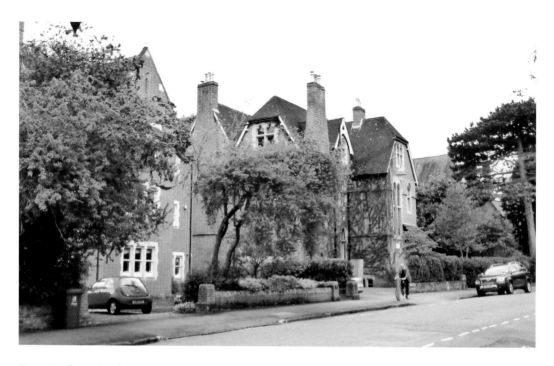

No. 9 Norham Gardens

Above: No. 9 Norham Gardens was designed by Charles Buckeridge (1832–73) and built in 1868, the first occupant being Montagu Burrows, the Regius Professor of Modern History. The building is of red-brick construction, with a steeply-pitched roof profile and prominent half-hipped gables that give it a slightly French appearance. *Below*: The drawing room of a mid-Victorian villa, as envisaged by William Wilkinson in his book *English Country Houses*. Wall-mounted candles appear to be the only form of lighting.

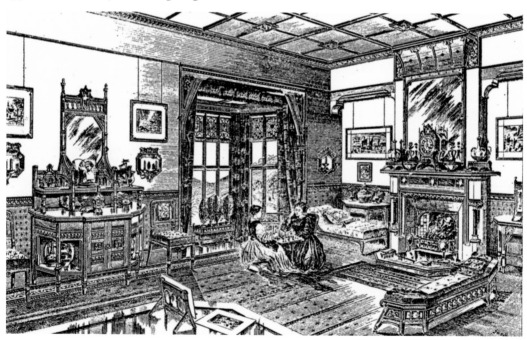

No. 3 Norham Gardens

Above: No. 3 Norham Gardens was also designed by Charles Buckeridge. Built in 1868 for Henry Hammons, a bookseller, the house is of yellow brickwork, with distinctive fenestration and an unusual 'stepped' porch. *Below*: The master bedroom of a typical Victorian house, as portrayed in *English Country Houses*. The dressing table is situated in the bay window, while a washstand with matching 'his' and 'hers' water jugs can be seen behind the bed.

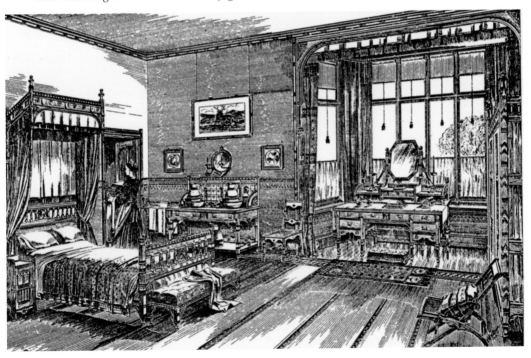

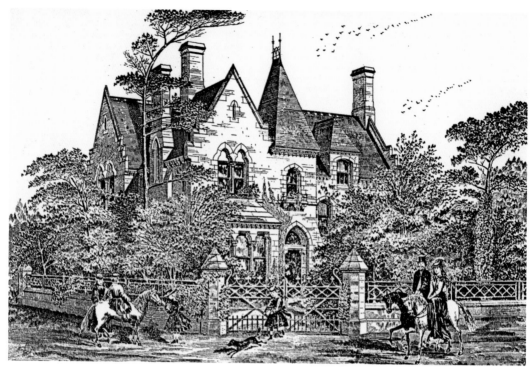

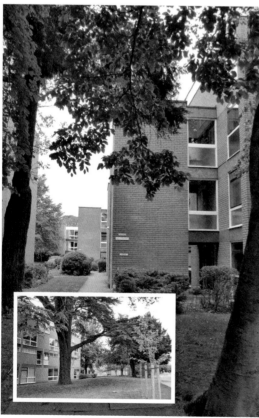

The Walton Manor Estate – No. 113 Woodstock Road

The Walton Manor Estate was slightly earlier than the Norham Gardens Estate. In 1859, St John's College set up a committee to consider how an area of college land to the west of the Woodstock Road could be profitably developed. Samuel Seckham was selected as the first architect, but he was subsequently replaced by William Wilkinson, who designed a number of the new houses including No. 113 Woodstock Road, shown above, which was built in 1863 for Edwin Butler, a wine merchant. Victorian architecture was despised by mid-twentieth-century town planners and their friends in the architectural establishment, and in these circumstances many of the large North Oxford houses were threatened with destruction, one of the victims being No. 113, which was demolished in the 1960s. Its site is now occupied by a modern development known as 'Butler Close', which is shown in the lower illustration. *Inset*: A recent view showing Butler Close from the Woodstock Road.

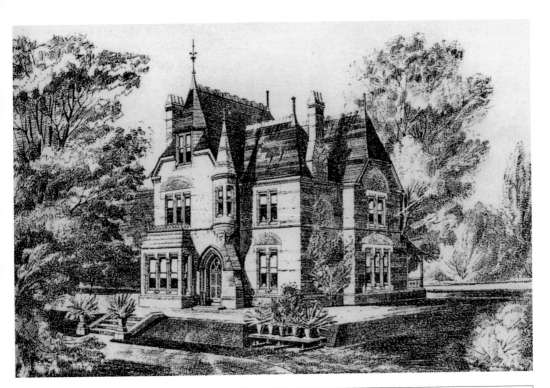

No. 60 Banbury Road

No. 60 Banbury Road, at one time known as 'Shrublands', was another typical North Oxford villa; it was designed by William Wilkinson and the first occupant was Thomas George Cousins, the proprietor of a chemist's shop in Magdalen Street. The house is of yellow-brick construction with Bath stone dressings, and when first built in 1869 it contained three reception rooms, five bedrooms and a conservatory, as well as a kitchen, cellars and other service rooms.

Study of the accompanying ground plan will reveal that, as is usual with Wilkinson's villas, the kitchen, scullery, larder and other service rooms were laid out in such a way that the servants could go about their daily work without impinging unnecessarily upon the master or his family – a servants' passage being provided alongside the main hallway.

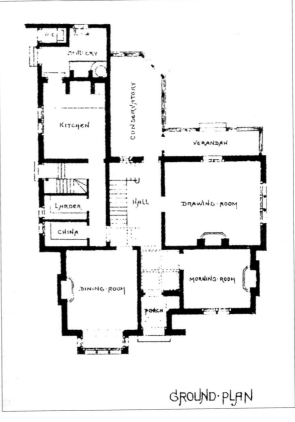

GROUND·PLAN

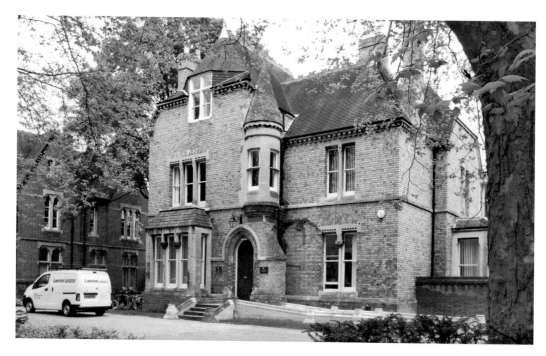

No. 60 Banbury Road & No. 82 Woodstock Road

Above: A recent view of No. 60 Banbury Road, which is now an integral part of Kellogg College, a constituent college of the University of Oxford; the elaborate finials have been removed, but the building is otherwise in excellent condition. *Below*: Completed in 1887, No. 82 Woodstock Road was designed by William Wilkinson in conjunction with his nephew, Harry Wilkinson Moore (1850–1915), the two architects having formed a partnership in 1881. William Wilkinson retired in 1886 and, thereafter, his nephew worked alone.

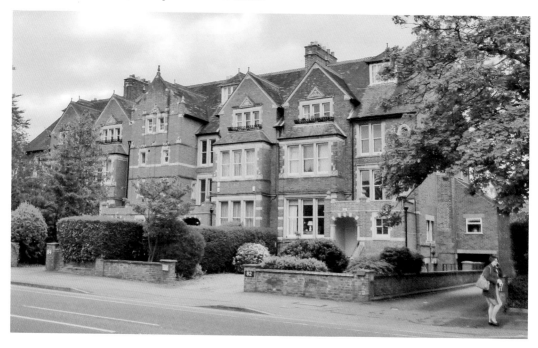

No. 31 Banbury Road

Built in 1866 for George Ward, No. 31 Banbury Road was another example of William Wilkinson's characteristic North Oxford villa designs. On 13 October 1866 *Jackson's Oxford Journal* opined that 'handsome villas' of this kind 'materially contribute to the appearance of the locality'. In a previous edition, the same journal had mentioned that Mr Wilkinson's villas were all equipped with 'Moule's patent earth closets, with self-activating floor apparatus'. The tall window that can be seen to the left of the front door provided ample light for the main stairway, while the oriel window to its left illuminated the bathroom. Sadly, No. 31 was demolished in the 1960s, and its site is now occupied by modern buildings.

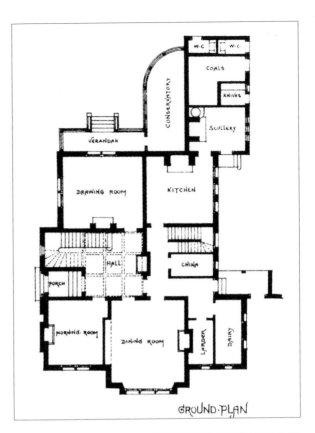

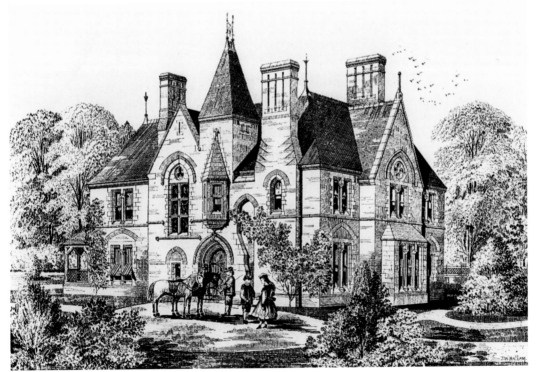

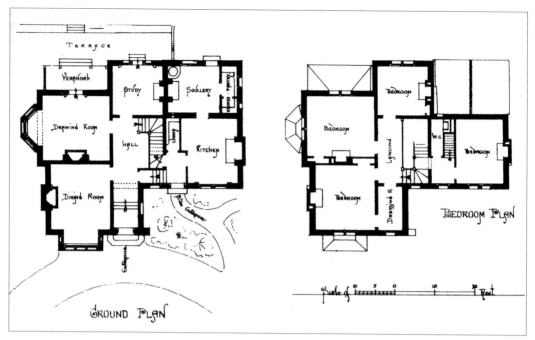

TERRACE

VERANDAH | STUDY | SCULLERY

DRAWING ROOM | HALL | KITCHEN

DINING ROOM

GROUND PLAN

BEDROOM

BEDROOM | W·C | BEDROOM

BEDROOM | DRESSING R

BEDROOM PLAN

Scale of Feet

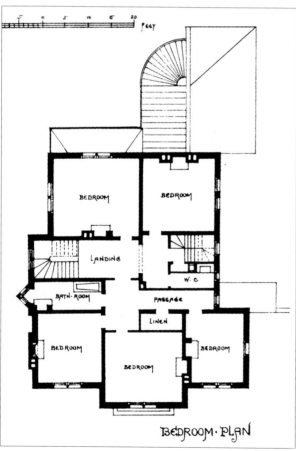

FEET

BEDROOM | BEDROOM

LANDING

W·C

BATH·ROOM | PASSAGE

LINEN

BED ROOM | BEDROOM

BEDROOM

BEDROOM·PLAN

Some Additional House Plans

Above: The floor plans of Edwin Butler's house at No. 113 Woodstock Road (*see page 26*) were published in *English Country Houses*. The ground floor incorporated two reception rooms and a 'study', together with the kitchen and service area, which were entirely separate from the 'family' rooms. This layout was echoed on the upper floor, which contained three main family bedrooms and a servants' bedroom above the kitchen. *Left*: The upper floor of No. 31 Banbury Road provided sufficient space for four 'family' bedrooms and a fifth bedroom for live-in servants; the bathroom on the top of the landing was intended for 'family' use, while the WC at the top of the 'back stairs' was presumably intended for the servants. On a footnote, it is often claimed that these mid-Victorian villas were built to accommodate 'married dons', though in reality this is incorrect, as dons were not allowed to marry during the mid-Victorian period.

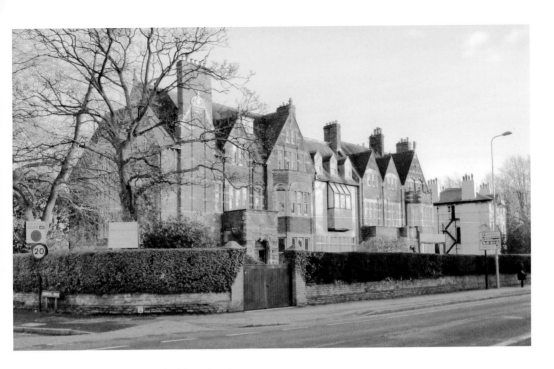

Wychwood & Summerfields Schools

Above: Founded in 1897 by Margaret Lucy Lee (1871–1955), daughter of the vicar of Leafield, and her friend Annie Sophia Batty (*d.* 1934), the Wychwood School moved to No. 74 Banbury Road in 1918, and it later acquired No. 72. These two large villas dated from 1885, and both had been designed by Messrs Wilkinson & Moore. It is seen here in 2012. *Below*: Summerfields School, *c.* 1928, about three quarters of a mile to the north, was founded as a Boys' Preparatory School in 1864 by Archibald and Gertrude Maclaren.

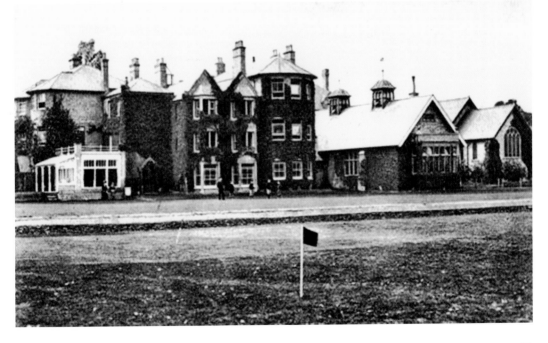

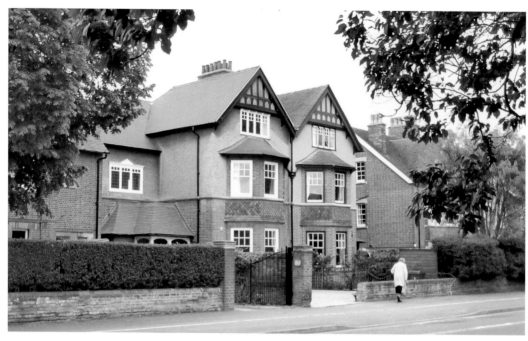

No. 217 Woodstock Road & No. 22 Museum Road

Above: No. 217 Woodstock Road was one of a pair of villas erected in 1900. Gothic architecture had gone out of fashion by the end of the Victorian period, and early twentieth-century houses tended to exhibit 'vernacular revival' features, such as tile-hung bay windows and 'Tudor' style timber-framing. The first occupant of No. 217 was Mrs Frances Richardson, the wife of a clergyman. *Left*: No. 22 Museum Road and the neighbouring properties were erected in 1873 as a speculative venture by John Dorn, a local builder. The most noteworthy occupant of No. 22 was perhaps Frederick Gaspard Brabant (1856–1929), a writer, teacher and private tutor who, as an undergraduate, had 'attained the rare distinction of adding a first in mathematical moderations to two firsts in classics'. He was also an enthusiastic local historian, who produced a number of informative guide books about Oxfordshire, Berkshire, Sussex, North Wales and the Lake District.

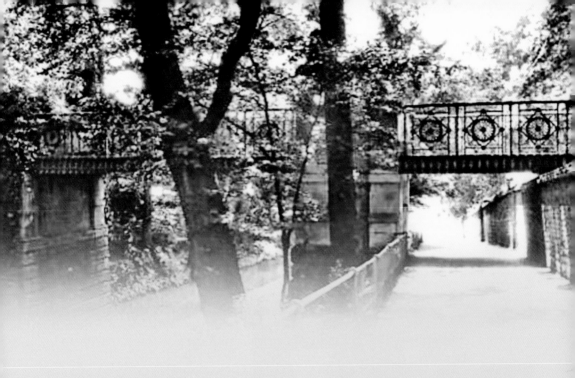

CHAPTER 2

Headington & East Oxford

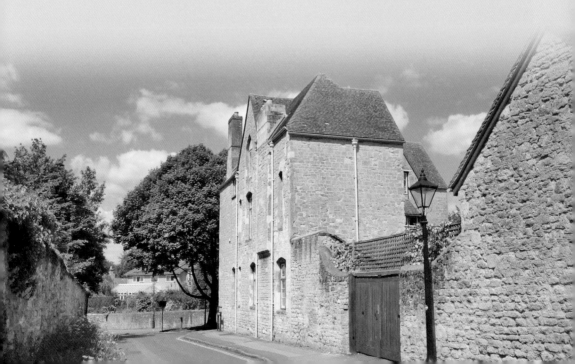

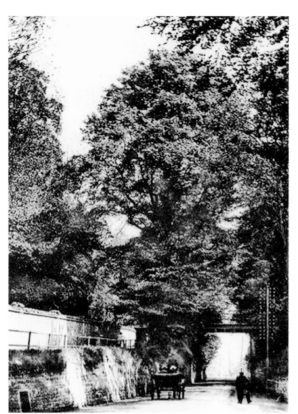

Headington Road & Bridge

In 1852, Gardner's *History, Gazetteer & Directory of the County of Oxford*, described 'the High road from Oxford to Headington' as 'broad and steep', with 'a fine terrace walk constructed by the general subscription of the University'. Hereabouts, according to legend, an Oxford student had once been attacked by a wild boar from Shotover Woods, but he 'escaped by cramming a volume of Aristotle down the throat of the savage beast'!

In 1824, a palatial house known as Headington Hill Hall was erected for the Morrell family, proprietors of Morrell's Brewery, and as the Morrell's land eventually extended over both sides of the road, William Wilkinson was asked to design an ornamental footbridge, which was built in 1866 and now forms a prominent local landmark. The old postcard view is looking east towards Headington around 1912, and the colour photograph was taken in June 2013.

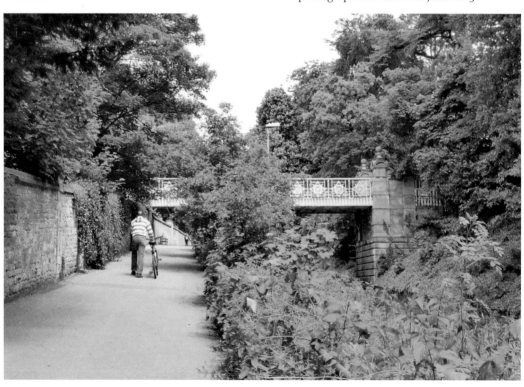

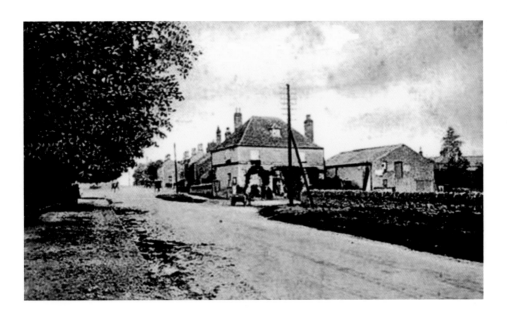

The Britannia at New Headington

Headington Road, which continues eastwards as 'London Road', now forms part of the A420 – a major thoroughfare for traffic heading into and out of Oxford. The upper view shows the Britannia Inn on the corner of London Road and Lime Walk around 1912. The scene is still semi-rural in character, although urban expansion was, by that time, well under way in nearby streets such as Windmill Road and Lime Walk. The colour photograph was taken from a similar position in 2012.

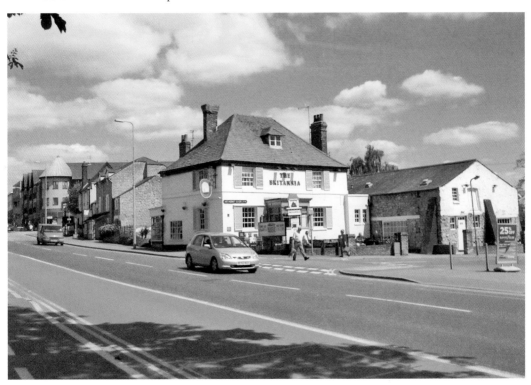

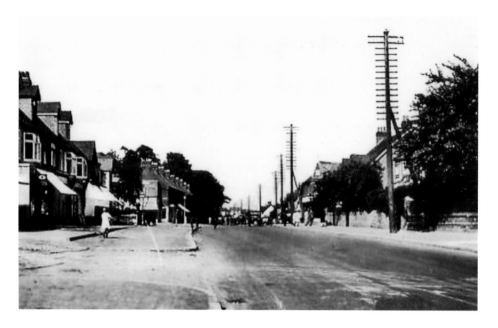

London Road, New Headington

Above: A general view of London Road, looking east around 1930. The Headington area was once entirely rural but, according to the 1933 *Little Guide to Oxford*, the original village had, by that time, become 'quite overshadowed by the large new suburb of Oxford, which includes, besides Headington, Highfield and Headington Quarry'. *Below*: A recent view of London Road in June 2013. The road junction visible in the distance gives access to Windmill Road and Old High Street.

Lime Walk, New Headington

Above: An early twentieth-century postcard view of Lime Walk, looking north towards London Road, with the red-brick façade of the newly-built All Saints church visible to the right. The corner shop that can be seen to the left of the picture was a post office and grocer's shop. *Below*: A recent view, taken from a position slightly further to the south in June 2013. Headington was incorporated into the City of Oxford in 1929.

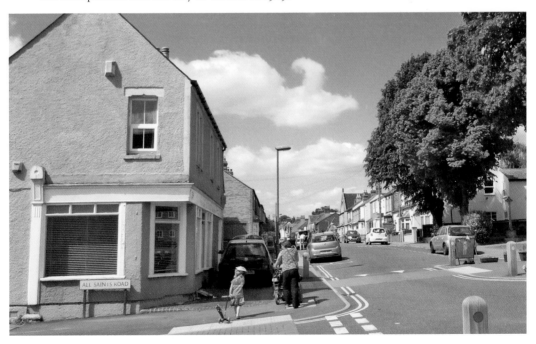

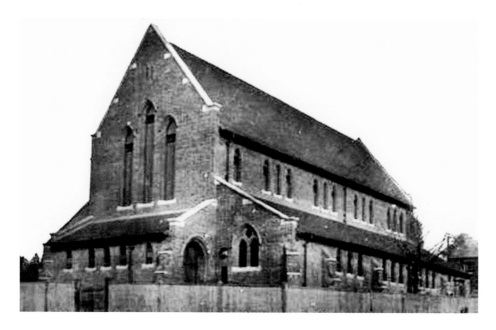

All Saints Church, New Headington

A closer view of All Saints church, which was designed by Arthur Blomfield & Son and consecrated on 29 May 1910. This new church was intended to cater for the growing district of New Headington, which had hitherto been served by a corrugated-iron mission church in Perrin Street. As originally built, the church consisted of a nave, side-aisles and a west porch, but a chancel was added in 1935. The upper view dates from around 1912, while the recent photograph was taken in 2013.

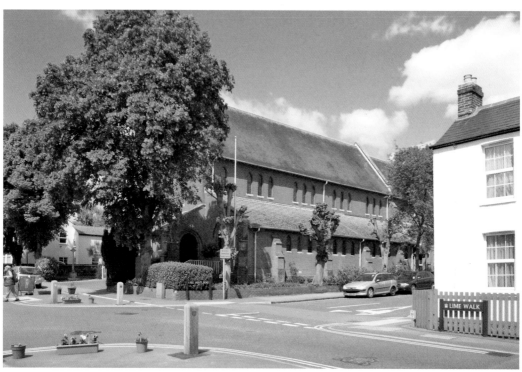

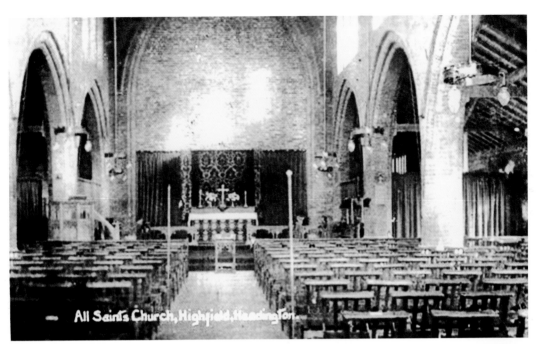

All Saints Church, Highfield, Headington.

John Wesley Woodward

A postcard view showing the rather bleak, bare-brick interior of All Saints church before the addition of the chancel. A plaque within the church commemorates John Wesley Woodward (1879–1912) of No. 2 Windmill Road, Headington, a cellist and member of the *Titanic*'s orchestra who, with his fellow musicians, played ragtime and other popular melodies as the great liner sank by the bows; most witnesses agree that, at the very end, the band played *Nearer My God to Thee*. The memorial plaque, which is difficult to photograph, is inscribed with the following words:

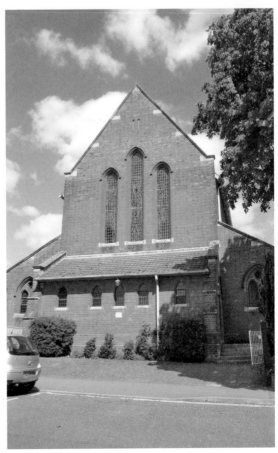

TO THE GLORY OF GOD AND IN
MEMORY OF
JOHN WESLEY WOODWARD
BANDSMAN ON THE S.S. *TITANIC*
WHO WITH HIS COMRADES
NOBLY PERFORMED HIS DUTY TO
THE LAST
WHEN THE SHIP SANK
AFTER COLLISION WITH AN
ICEBERG
ON APRIL 15 1912.
BORN SEPT 11, 1879.
'NEARER MY GOD TO THEE.'

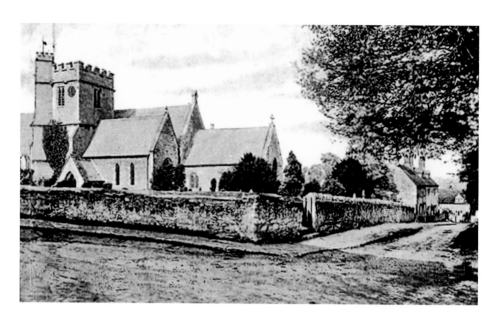

St Andrew's Church, Old Headington

Old Headington, which is linked to New Headington by Old High Street and Ostler Road, retains the atmosphere of a rural village, in spite of suburban encroachments during the nineteenth and twentieth centuries. The parish church, originally Norman, was enlarged at various times, and in its present form the building incorporates a nave, aisles, chancel, south porch and an embattled west tower. The upper view shows the church around 1912, while the colour photograph was taken in June 2013.

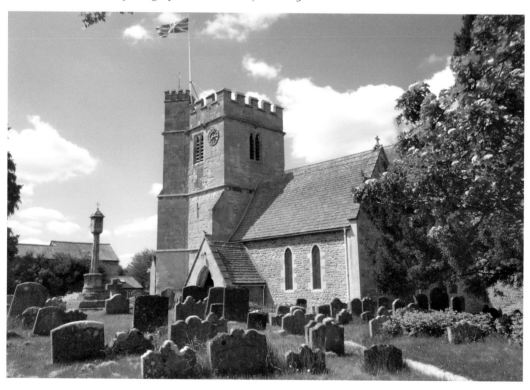

Thatched Cottages in Old Headington

This postcard view of Headington village, dating from around 1910, depicts a row of old thatched cottages at the west end of St Andrew's Road. Sadly, these traditional stone buildings were demolished in the 1930s and a row of modern houses, designed by Ronald Fielding Dodd, was erected in their place. The lower picture, taken in 2013, shows the replacement buildings, which are numbered from 27 to 33. Their continuous frontage maintains the profile of the demolished cottages, but they are set further back from the street.

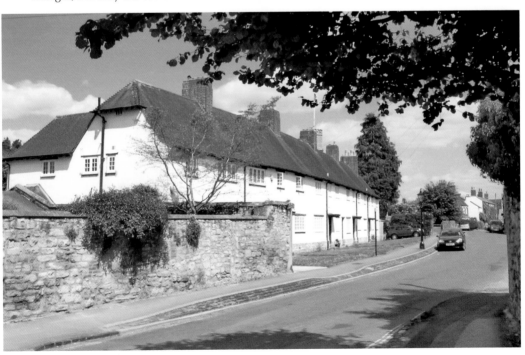

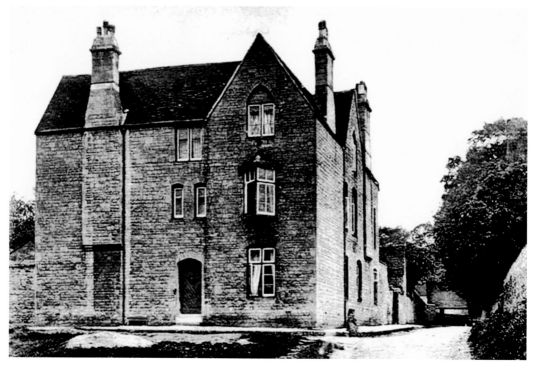

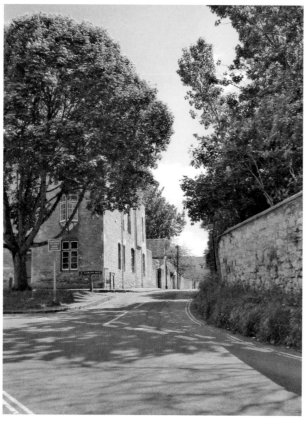

St Andrew's House, Old Headington

The substantial Victorian building known as St Andrew's House is situated in Old Headington, at the corner of St Andrew's Road and Osler Road. It is of Cotswold-stone construction, and served as a vicarage from 1881 until 1977. The upper view shows the building during the early years of the twentieth century, while the colour view was taken over a century later in June 2013. The house is partially hidden by a large tree, although the Osler Road frontage can be clearly seen.

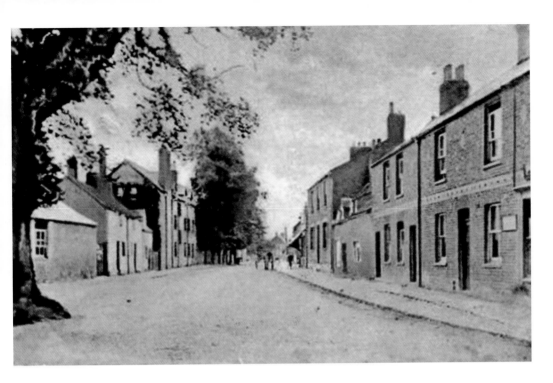

Old Headington Village

Above: A colour-tinted postcard view of Old Headington village, looking southwards along Old High Street around 1912. The large building that can be seen in the distance is a former farmhouse known as Linden House, which was substantially rebuilt during the Victorian period. *Below*: This recent view reveals that several old cottages have been replaced, but Linden House – now The Priory – has survived; it was purchased by a community of Dominican Sisters in 1923, and acquired by the Congregation of the Sacred Heart in 1968.

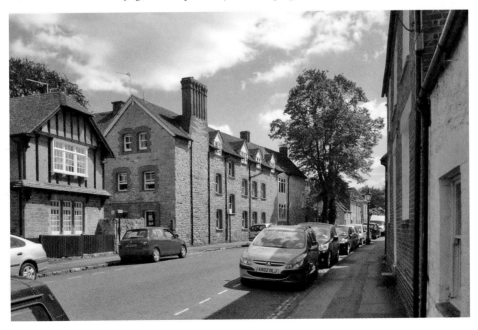

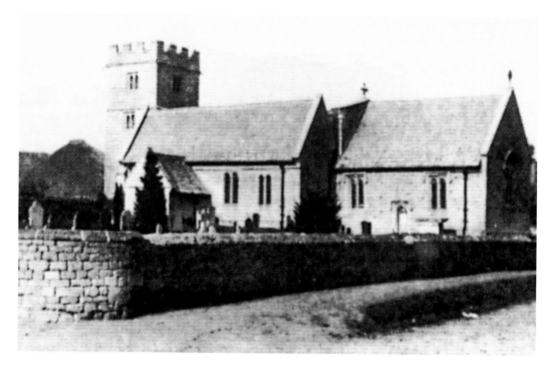

St Nicholas Church, Old Marston

Marston, to the north-west of Headington, consists of the suburb of New Marston and the original Old Marston village, which were absorbed into Oxford in 1929 and 1991 respectively. The upper view shows Old Marston parish church, which consists of a nave, aisles, chancel, south porch and west tower. Although the exterior details of the church reflect the Perpendicular style, the nave arcades and chancel arch are Early English. The photographs were taken *c.* 1920 and in June 2013.

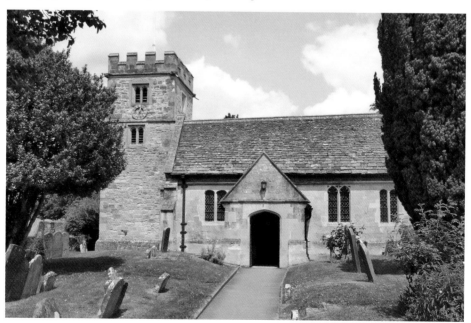

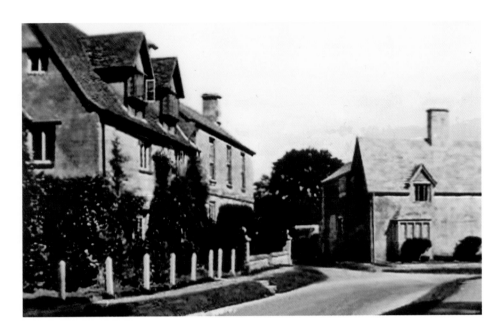

Cromwell's House, Marston

This seventeenth-century house in Old Marston was the home of Unton Coke, a leading Parliamentarian during the Civil War, and it is said to have been the headquarters of the New Model Army during the siege of Oxford – negotiations leading to the formal surrender of the city were held here in May 1646, and the Royalist garrison finally capitulated on 20 June. The upper picture shows Cromwell's House and neighbouring buildings around 1912, while the recent view was taken in 2013.

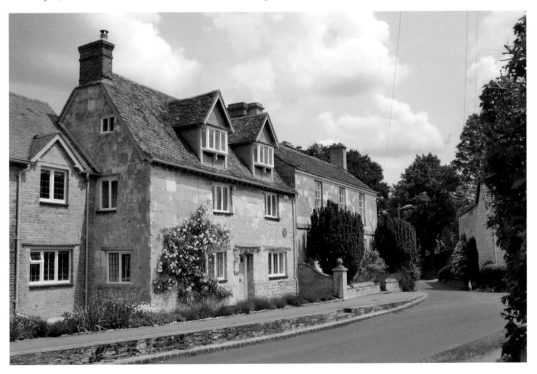

CHAPTER 3

St Clement's, Cowley &
South Oxford

St Clement's & The Plain

St Clement's, one of Oxford's earliest suburbs, originated in the tenth century, when a *brycggesett*, or 'bridge-settlement', grew up on the east side of the River Cherwell. This suburb had its own church, which was dedicated to St Clement – a saint associated with areas of Danish settlement. The medieval church was demolished in 1829/30, leaving an open space known as 'The Plain' at the junction of St Clement's Street and the Iffley and Cowley roads. The photograph shows The Plain around 1920 and in 2013. *Previous Page:* Victorian terraces in the Iffley Road.

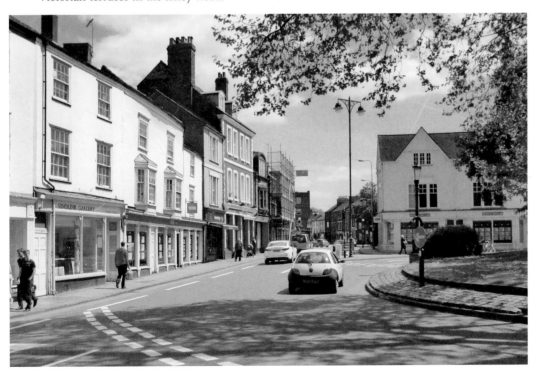

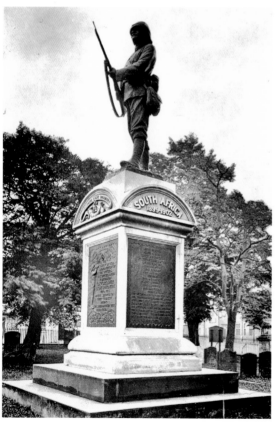

The Boer War Memorial

Oxford's Boer War memorial, commemorating 142 members of the Oxfordshire Light Infantry who had died in South Africa, was unveiled in the old churchyard on The Plain on 19 September 1903. The monument initially comprised four bronze tablets upon a Portland stone plinth, but a 7-foot bronze figure of a soldier was subsequently added, and in 1906 *The Oxfordshire Light Infantry Chronicle* reported that this additional work had been 'entrusted to Messrs Boulton & Sons, sculptors of Cheltenham, the artist being Mr J. Hyatt, a constant exhibitor at the Royal Academy; while the casting was carried out by Messrs Singer of Frome'.

The memorial was removed in the 1950s and, as shown in the upper picture, its site is now occupied by a roundabout. The lower photograph shows the memorial shortly after its completion in 1906; it is now at Edward Brookes Barracks, near Abingdon.

St Clement's Church

The present St Clement's church, in Marston Road, was designed by Daniel Robertson and consecrated on 14 June 1828. The site was donated by Sir Joseph Locke, and the church, which consists of a nave, side-aisles and west tower, was paid for by public subscription. The upper view shows the church during the early years of the twentieth century, while the colour view was taken in 2013. Although the building is supposedly a 'Norman-style' structure, its symmetrical appearance reflects Georgian ideas of 'taste'. *Inset*: A detailed view of the tower.

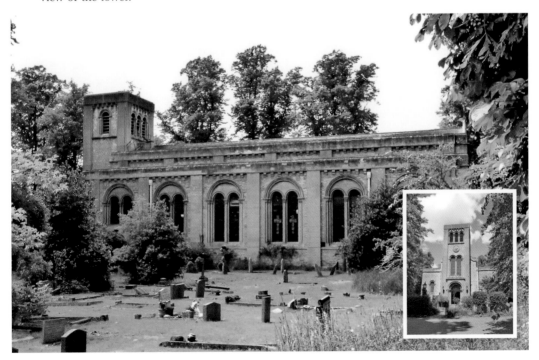

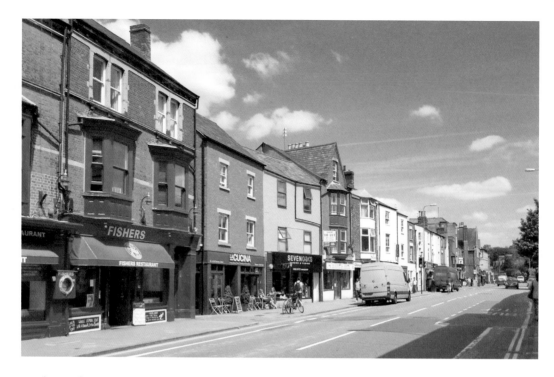

St Clement's Street

St Clement's Street is one of three busy thoroughfares that radiate from The Plain, the other two being Cowley Road and Iffley Road. These two recent views are both looking east towards Headington, the lower photograph having been taken from a position slightly further to the east. The brick building with the tall gable was St Clement's Mission Hall, while the former Victoria Café can be seen to its right, on the corner of St Clement's and Boulter Street.

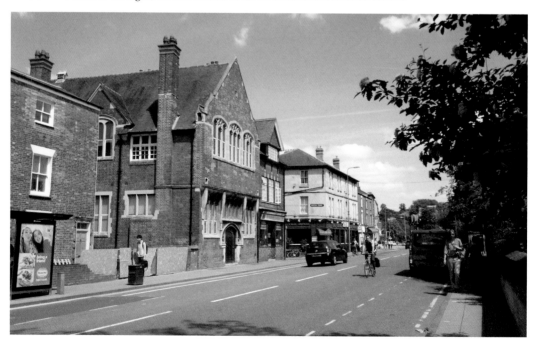

St Clements: The Victoria Café

This Edwardian postcard view provides a more detailed glimpse of the Victoria Café. This distinctive building was erected around 1886 and was, for a period of over thirty years, run as a café and boarding house by Walter Hazel and his wife Emma, who offered 'well-aired beds' and 'good and reasonable accommodation for cyclists and commercials'. Mr Hazel died in 1938, his wife having predeceased him by just six months; thereafter, the building was used for a time as an annexe to the neighbouring Mission Hall, though it subsequently became a 'Gospel Book Depot'; it is now the St Andrew's Christian Bookshop, as shown in the recent colour photograph.

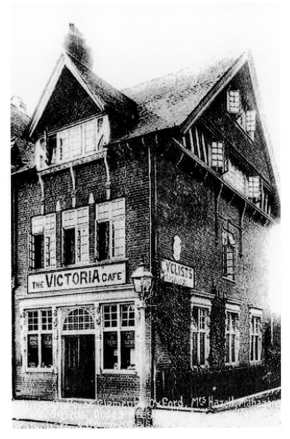

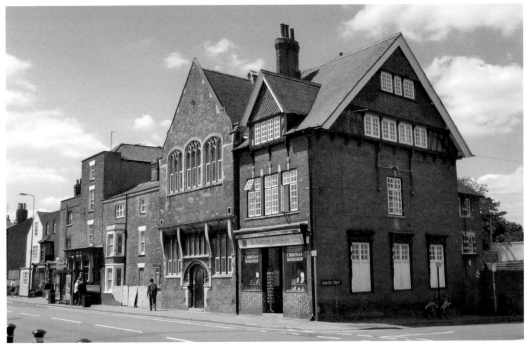

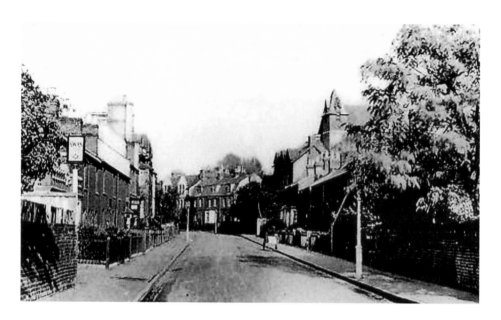

Marston Street

Marston Street is one of many side streets in the St Clement's area. It forms a link between the Cowley and Iffley roads, and was first developed during the 1850s. The street contains a variety of different buildings, including two-storey terraced houses and a number of somewhat larger villas, as can be seen in the accompanying photographs. The upper view dates from around 1912, while the colour photograph was taken a century later in 2013.

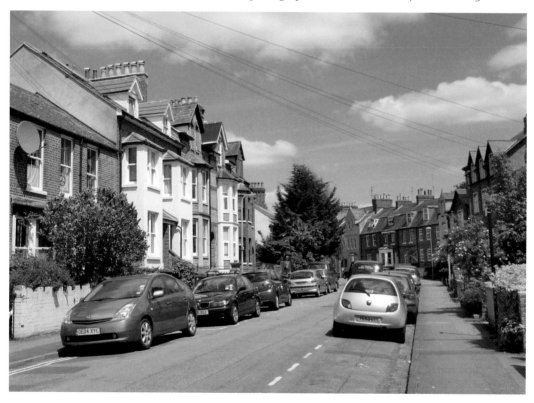

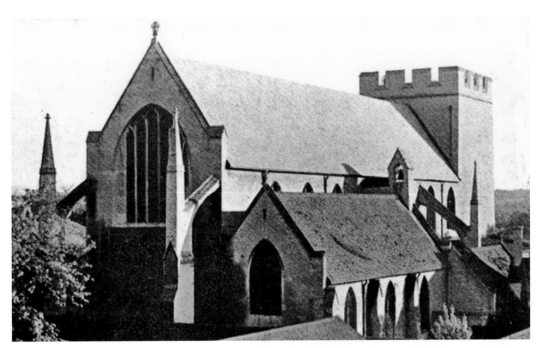

St John the Evangelist Church

The church of St John the Evangelist in Iffley Road was built as a chapel for the Society of St John the Evangelist, an Anglican religious order that had been founded by Richard Meux Benson (1824–1915), Vicar of Cowley, in 1865. This impressive Victorian church was completed in 1896, the architect being Thomas Bodley (1827–1907), although the west tower was not added until 1902. The church is now part of an Anglican theological college known as St Stephen's House.

The upper photograph provides a general view of the church from the north-east, and was probably taken shortly after the completion of the tower. The colour view is a detailed study of the west tower, which features three tall buttresses – the massive centre buttress is adorned with a small relief carving of the Crucifixion. *Inset*: A detailed view of the Crucifixion; the female figures on either side represent St Mary and St John the Evangelist.

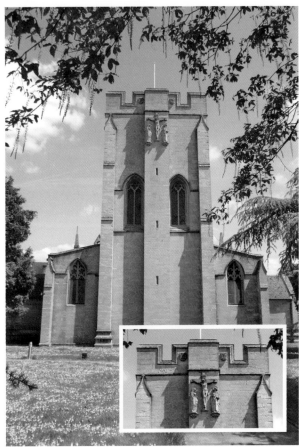

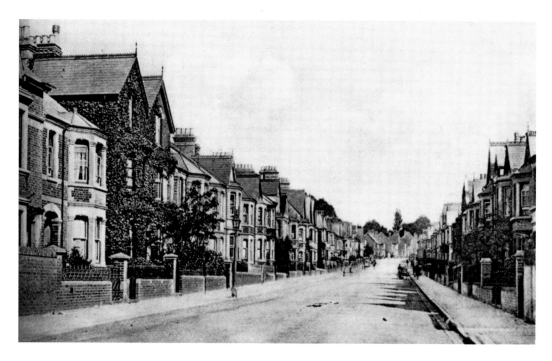

Divinity Road

Above: Running from north-east to south-west, Divinity Road was laid out by The Oxford Industrial & Provident Land & Building Society in 1891. When first erected, these neat, brick-built villas would typically have been occupied by bank clerks, shopkeepers, small businessmen and other lower middle-class residents. *Below*: A recent view, taken in 2013; the gas lamps have been replaced by electric lights, while the iron railings in front of the neat, brick-built houses were taken away for scrap during the Second World War.

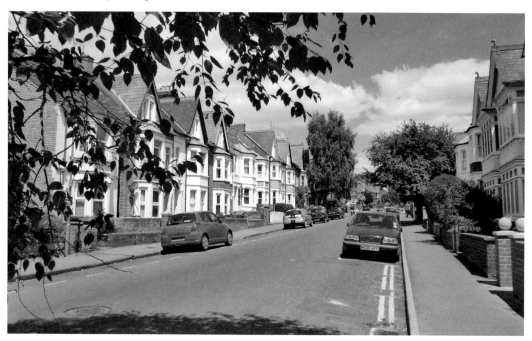

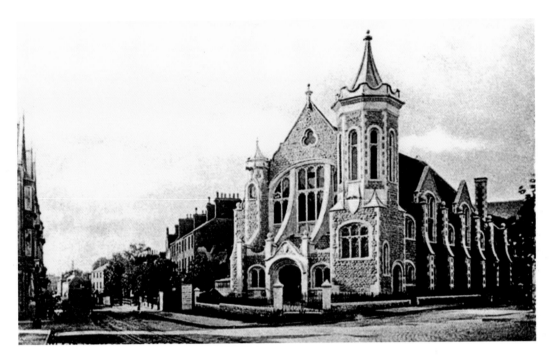

Cowley Road Wesleyan Chapel

Designed by Stephen Salter, the Cowley Road Methodist chapel was built by Messrs Kingerlee & Sons of Oxford, and opened in 1904. It was able to seat 700 worshippers, while the adjacent school could accommodate 500 pupils. With its curious turrets and boldly-curved buttresses the building is unexpectedly flamboyant for a Nonconformist chapel; the upper view shows building shortly after its completion, while the colour photograph was taken in June 2013.

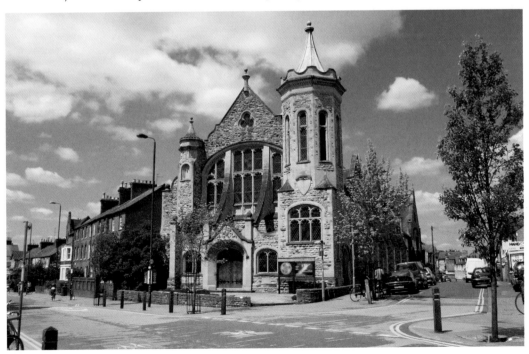

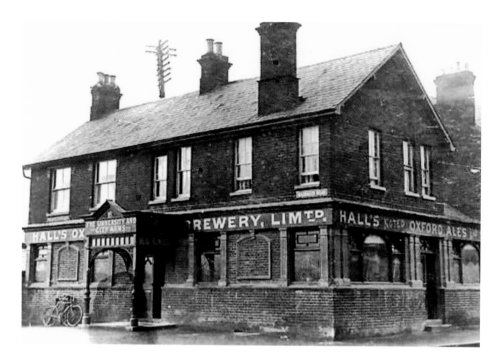

The University & City Arms

Above: This somewhat forbidding Victorian pub was situated on the corner of Cowley Road and Magdalen Road, in convenient proximity to the Cowley Road tramway terminus. The landlord in 1895 was William King. *Below*: The building was demolished by Messrs Ind Coope around 1937 and, in its place, the brewery firm built a slightly larger pub with three bars. In 1995, the pub was renamed The Philosopher & Firkin by Allied Domecq, but it is now known as the City Arms.

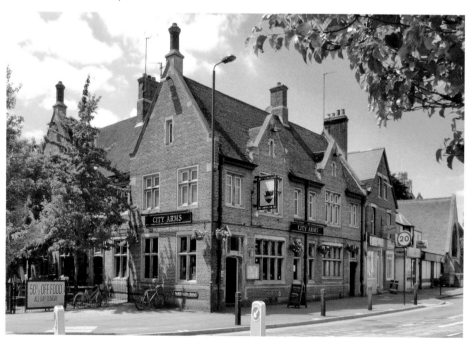

Bedford Street

Bedford Street is one of a number of side streets in a residential area to the west of the Iffley Road and, like Marston Street and Divinity Road, it was intended to provide for the needs of Victorian lower-middle-class households. The upper view, from a postcard of *c.* 1912, is looking westwards, while the colour photograph, taken in June 2013, is looking east towards Warwick Street. These nineteenth-century villas are only a short distance away from the River Thames.

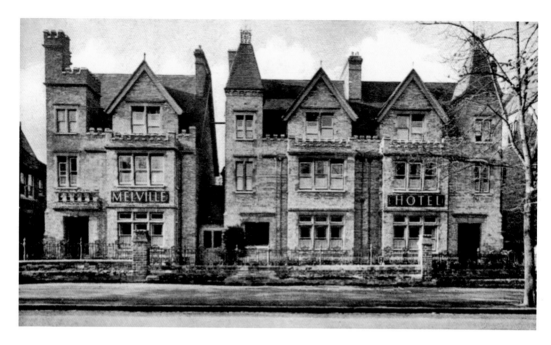

The Melville Hotel

Nos 214–218 Iffley Road, formerly The Melville Hotel, are now used as student accommodation. At first glance, these substantial Victorian buildings seem to have an affinity with the nineteenth-century villas in North Oxford, although they are in an urban setting beside a busy main road, rather than an exclusive suburb. Advertisements reveal that, in the mid-1930s, the Melville Hotel had thirteen double or twin rooms; bed and breakfast was available 'from 7s 6d', while the cost of an evening meal was 3s 6d.

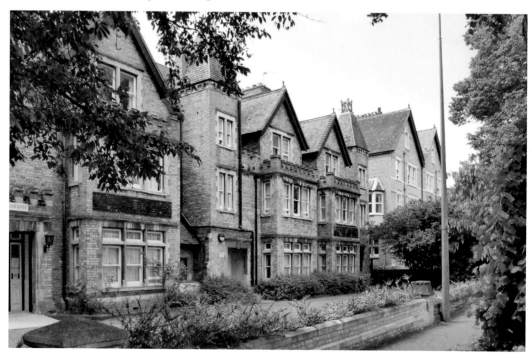

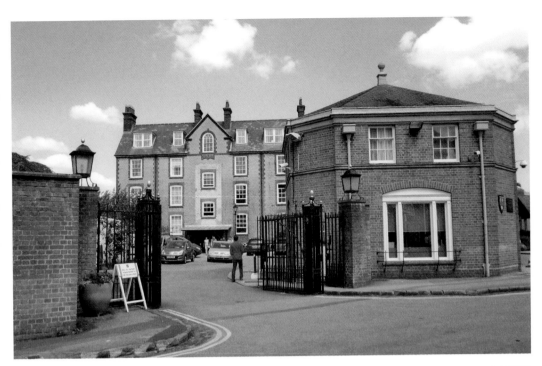

St Hilda's College

St Hilda's College was founded in 1893 by Dorothea Beale (1831–1906), the Principal of Cheltenham Ladies' College. Men have been admitted since 2008, but St Hilda's was, until that time, an exclusively female establishment. The college, which is sited in attractive surroundings beside the River Cherwell, boasts a diverse range of buildings, some of which pre-date the college, while others were added in the nineteenth and twentieth centuries.

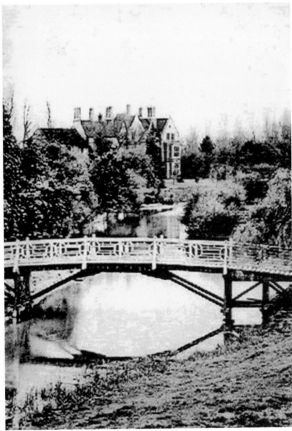

The upper picture shows the main gateway to the college; the lodge was built as recently as the 1950s, although parts of the 'Hall Building' behind it date back to the 1780s. The lower view provides a glimpse of the college from the riverbank. The Victorian Gothic building visible in the distance is Cherwell Hall, which was originally a private house, and later became a teachers' training college; the property was acquired by St Hilda's in 1902, and it is now known as 'The South Building'.

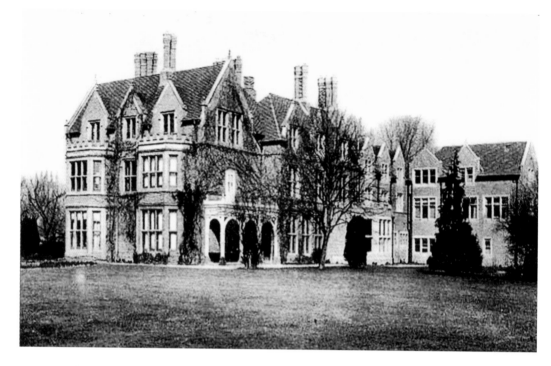

St Hilda's College

Above: This Edwardian postcard view shows Cherwell Hall, which was designed by William Wilkinson and erected in 1878. *Below*: The present 'Hall Building' was built around 1780 as a private house for Dr Humphrey Sibthorp (1713–97), Sherardian Professor of Botany. It subsequently became the home of his son, John Sibthorp (1758–96), the celebrated botanist and author of *Flora Oxoniensis*, a guide to the plants of Oxfordshire. Sibthorpe's main work, *Flora Graeca*, was published many years after his death.

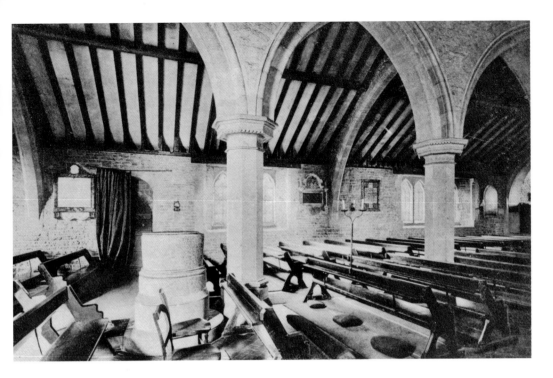

St James's Church, Cowley

Although now regarded as a sprawling outer suburb of Oxford, Cowley originally comprised the villages of Temple Cowley and Church Cowley. The church of St James, in Church Cowley, was rebuilt by G. E. Street during the 1860s, the most significant modification carried out at that time being the addition of a much-enlarged nave, which now dwarfs the rather stubby west tower. The upper view shows the interior of the church around 1912, while the colour photograph was taken in June 2013.

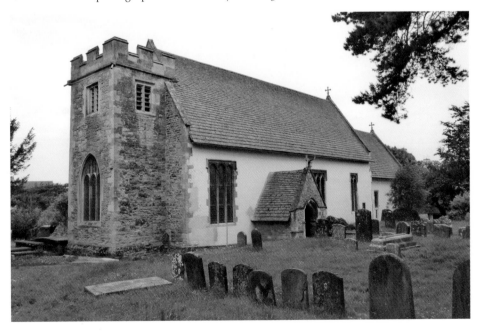

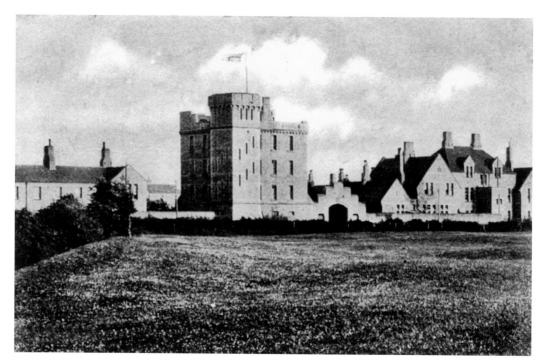

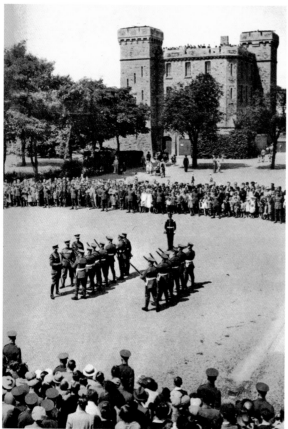

Cowley Barracks

Cowley Barracks was built in connection with the Cardwell reforms, which were initiated between 1869 and 1871 by Edward Cardwell (1813–86), the Secretary of State for War. It was decided that a network of regional military 'depots' would be established, and in 1873 *The Times* reported that the War Office purchased 20 acres of land in what was then open countryside, about 2 miles south-east of Oxford. Despite protests from Oxford University, construction of the barracks proceeded apace between 1874 and 1876, most of the building work being carried out by Messrs Downs & Co. of Southwark at a contract price of £45,000. The depot was opened on 7 June 1876, and the the first units to occupy the site were the 52nd (Oxfordshire) Light Infantry and the 85th (Bucks Volunteers) Regiment. The upper view shows the Barracks around 1912, while the lower photograph was taken during an 'Open Day' in 1938.

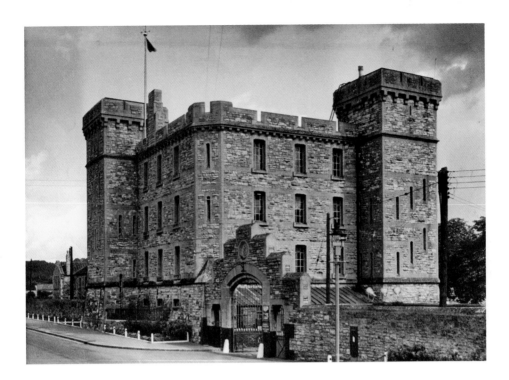

Cowley Barracks: The Keep

Above: The most obvious feature of the barracks was a tall, castle-like building known as 'The Keep'. This distinctive structure incorporated four full stories, together with two somewhat taller stair towers at the north-western and south-eastern corners of the building. The medieval theme was further underlined by the provision of crenellations around the parapet of the main block and on top of the towers, the latter being boldly machicolated. *Below*: A sketch plan showing the layout of Cowley barracks.

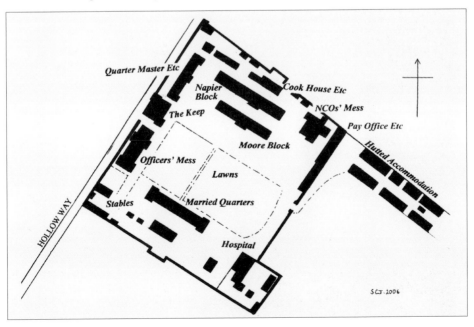

63

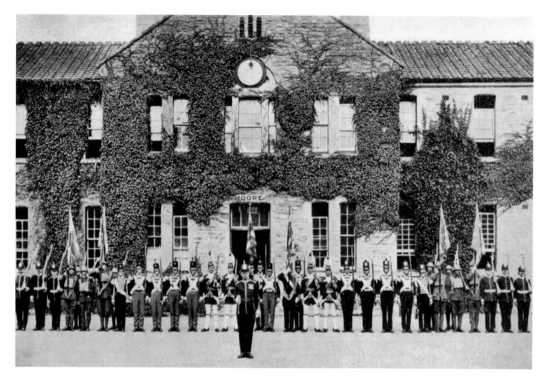

Cowley Barracks: Moore Block

The barracks contained a range of accommodation, including offices, mess rooms, an armoury, stores, married quarters, a guardroom, cook-house and stables, as well as a hospital. There were, in addition, two typical Victorian barrack blocks for the rank-and-file, and these were known as Moore Block and Napier Block. The upper view shows Moore Block in 1926 during a 'Pageant of Time' military tattoo, while the lower photograph shows Napier Block in 2007.

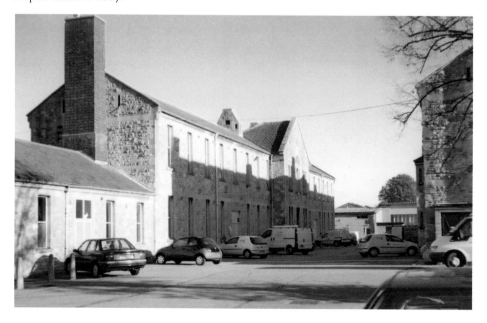

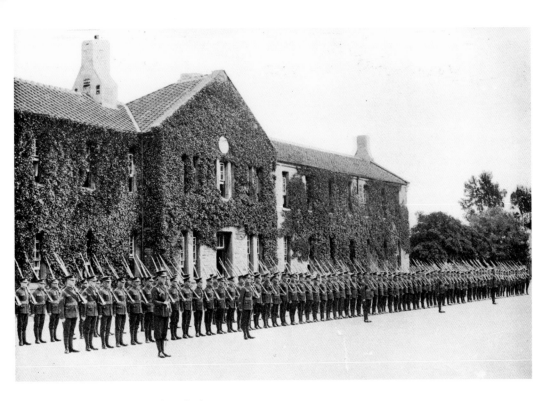

Cowley Barracks: Napier Block

Above: A presentation parade in progress outside Moore Block on 14 June 1930. *Below*: The facilities at Cowley were run down during the 1960s, the two barrack blocks being sold to GPO Telephones in 1965 – although the Officers' Mess remained in use as a Royal Green Jackets regimental office until 1968. The keep was, unfortunately, demolished, but Napier Block is still extant, as shown in this 2007 colour view. The neighbouring officers' mess building is now part of Oxford Brookes University.

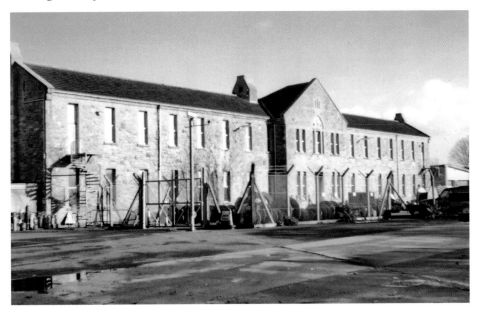

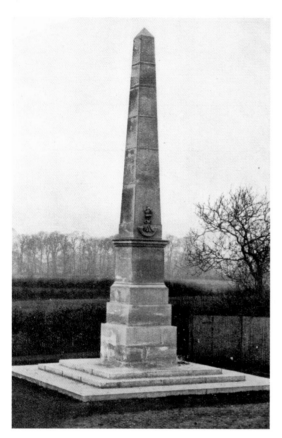

The Oxfordshire & Buckinghamshire Light Infantry Memorial

Towards the end of 1920, it was decided that the 5,878 members of the the Oxfordshire & Buckinghamshire Light Infantry who had lost their lives in the First World War would be commemorated by a Regimental war memorial. The architect Sir Edward Lutyens (1869–1944) was commissioned to design the memorial, which was in the form of a Portland stone obelisk, some 29 feet in height. It was hoped that the new memorial would be sited in convenient proximity to Cowley barracks but, in the event, problems with land acquisition meant that the obelisk, which was unveiled on 11 November 1923, was placed in what was then 'the corner of an orchard at the junction of the Henley and Cowley roads as they enter Oxford from the east'. The upper view shows the memorial surrounded by open countryside in 1923, whereas the recent photograph reveals that the area has now been thoroughly suburbanised. *Inset*: The cap badge of the Oxfordshire & Buckinghamshire Light Infantry.

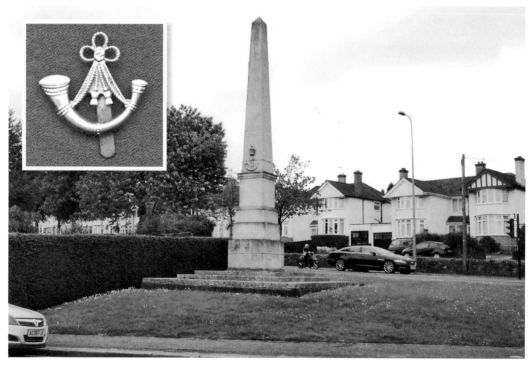

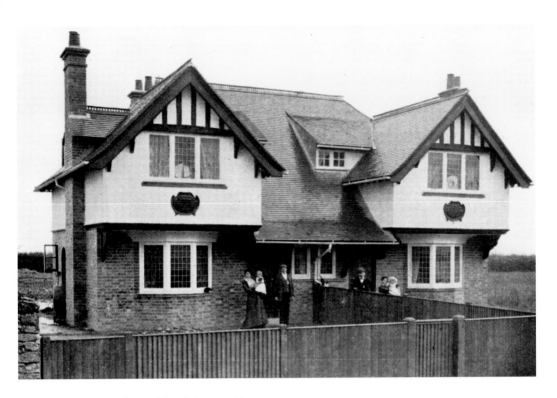

Cowley Barracks: Soldiers' Cottage Homes

These two cottages, which were paid for by public subscription, were erected in Cowley High Street to accommodate disabled soldiers, and to commemorate those who had died in the Boer War. The first occupants were Private W. Tripp, who lost his eyesight in South Africa, and Private J. Kearsley, who was severely wounded at Klip Kraal. One of the cottages is now used by a car valeting firm, while the other is the Cufa's Lea Veterinary Centre, as shown in the colour photograph.

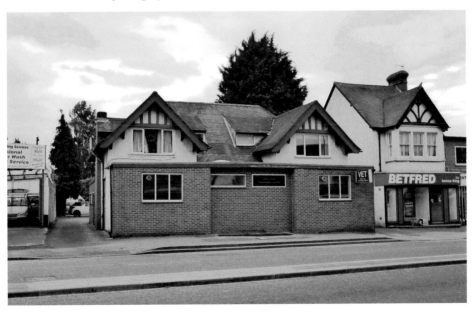

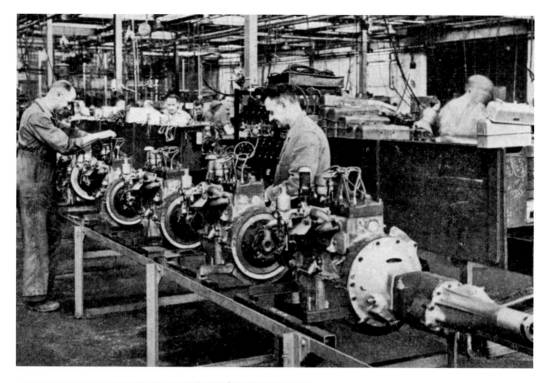

MORRIS
leads again

YET again MORRIS leads at Olympia. For 1931 improved specifications, more comprehensive equipment, important price reductions and a wider range of models, further consolidate the proud position of leadership in value which MORRIS cars have held so consistently in the past.

MORRIS value cannot be measured by low first cost alone. Sound design, comfort, economy, reliability, performance, complete equipment, quality of material and workmanship, low depreciation and country-wide service facilities, all contribute to making MORRIS value unapproachable. You can make no safer purchase.

STAND
108

Write for New Catalogue to Enquiries Dept. "Ti" Cowley

MORRIS MAJOR SIX

A new light six-cylinder 15 h.p. model with a sparkling road performance. Equipment includes air cleaner and fume consuming engine head, automatic radiator shutters, oil cleaner, grouped chassis oiling, powerful four-wheel brakes and full body equipment. Fabric Sports Salonette illustrated £215.

CHROMIUM
FINISH AND
TRIPLEX GLASS
STANDARD

Four-cylinder models from £125.

Motor Houses from £9 15s. carriage fwd. Deferred terms arranged.

MORRIS-COWLEY

The 11.9 h.p. Morris-Cowley for 1931 possesses greater engine power and is fitted with improved brakes, Bishop finger-light cam-type steering, grouped chassis oiling and a larger radiator and scuttle, which together with new body lines give a greatly enhanced appearance. Saloon £185.

BUY BRITISH AND BE PROUD OF IT

William Morris & the Origins of Cowley Works

Born in Worcester, the eldest son of Frederick Morris of Witney and his wife Emily, William Morris (1877–1963) attended Cowley village school until the age of fifteen, and having been apprenticed for a short time to an Oxford bicycle-maker, he set-up his own business at the age of just sixteen. The new venture prospered, and in 1913 Morris produced his first motor car – the 2-seater Morris Oxford. In 1912, Morris rented a former school at Cowley known as the Military College, which he adapted for use as a car factory. An additional building, known as the Old Tin Shed, was built to the north of the school, while 'B-Block' and the main production lines were added in the 1920s and 1930s respectively; by 1939, the car plant employed over 2,000 people. The upper view shows car engines being assembled, while the lower illustration shows a Morris advertisement from 1931.

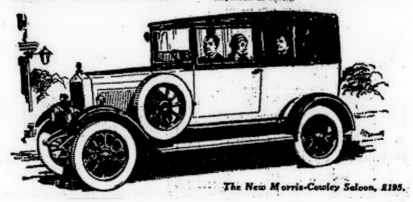

A full range of 1927 Morris models is available for inspection at ease and leisure at the Acton and New Bond Street Depots of our London Distributors, Messrs. Stewart & Arden, Ltd.

PRICES FROM £148 10s.

Prospective Purchasers from Overseas should communicate direct with our Export Department at Cowley.

The new 15.9 h.p. Morris-Oxford is shown in Chassis form at Olympia. A complete five-seater is available for inspection at Acton.

The New Morris-Cowley Saloon, £195.

Morris Motors & the Pressed Steel

Above: A further Morris advertisement, from around 1927, depicting 'the new Morris-Cowley saloon', which was reasonably priced at just £195. *Below*: Engines being tested in the Morris factory at Cowley. By 1930, Morris Motors had overtaken Ford as Britain's largest car manufacturer. William Morris was awarded a baronetcy in 1929, and in 1938 he became Viscount Nuffield. In addition to his role as an industrialist, Morris was also a noted philanthropist, who donated more than £30,000,000 to charitable causes.

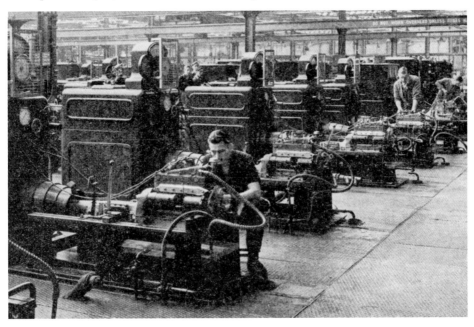

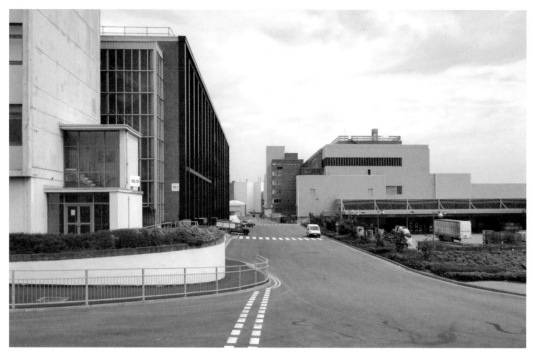

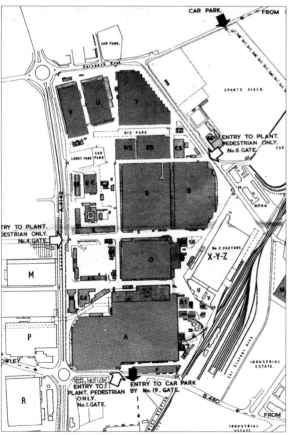

Morris Motors & the Pressed Steel

In 1926, Morris had opened the Pressed Steel body plant at Cowley as a new joint venture with the Budd Company of America and J. Henry Schroder, a merchant bank. Morris and the Budd Company subsequently withdrew, leaving Pressed Steel as an independent concern; there were thus two factories at Cowley, although both eventually became part of the British Motor Corporation (later British Leyland).

After many vicissitudes, the Cowley factories were acquired by BMW. The North and South Morris works were demolished, but the former Pressed Steel site was modernised and re-equipped so that it could produce an all-new version of the highly successful MINI. The upper view shows the part of the MINI plant in 2013, while the accompanying plan shows the layout of the Pressed Steel site in 1976, by which time it had become the Cowley Body Plant. Over 20,000 people worked at Cowley in the 1970s, whereas today's workforce is around 3,700.

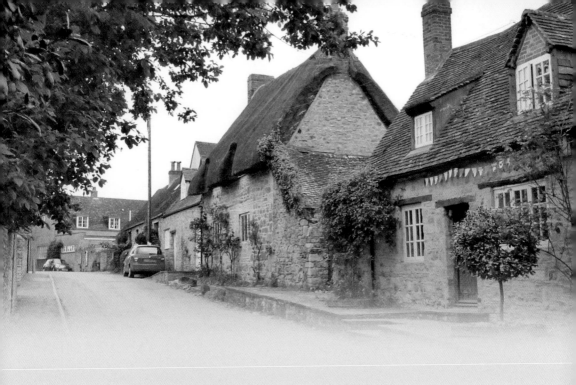

CHAPTER 4

Oxford Villages

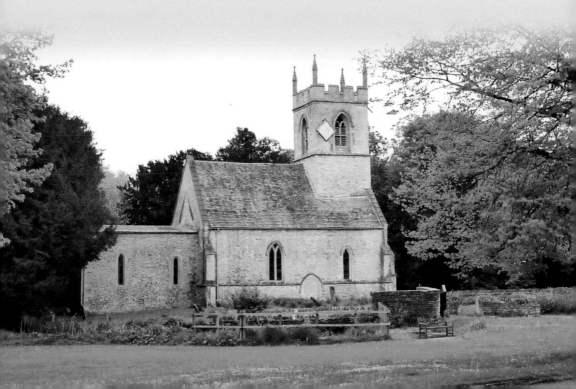

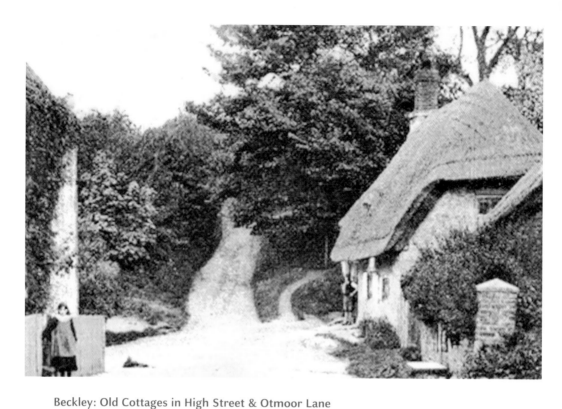

Beckley: Old Cottages in High Street & Otmoor Lane

Situated on high land to the north-east of Oxford, Beckley is a Cotswold-style village in well-wooded surroundings. Beckley was one of the 'seven towns of Otmoor' and, prior to enclosure in the early nineteenth century, the villagers had the right to graze their cattle, sheep and geese on the nearby moor. These two views are looking eastwards along the High Street towards Otmoor Lane. The upper view is an Edwardian colour-tinted postcard, whereas the lower photograph was taken in May 2013.

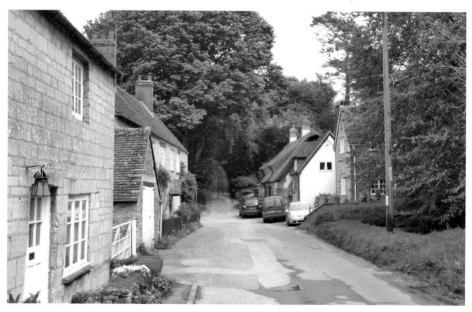

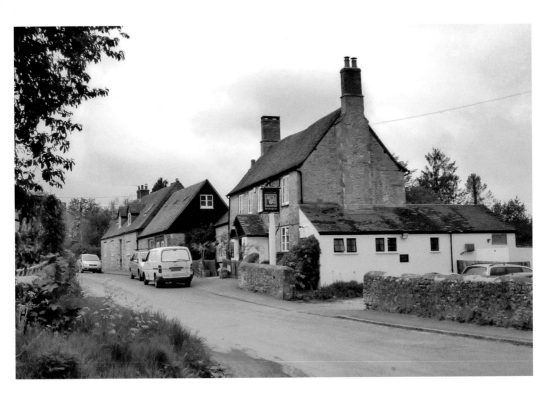

Beckley: High Street & the Abingdon Arms

The recent photograph was taken in May 2013, while the sepia postcard probably dates from around 1950; both of these views are looking westwards along the High Street, with the Abingdon Arms pub featuring prominently to the right. It is interesting to note that Beckley High Street appeared, albeit briefly, in an episode of the popular ITV detective series *Midsomer Murders* entitled 'Electric Vendetta'.

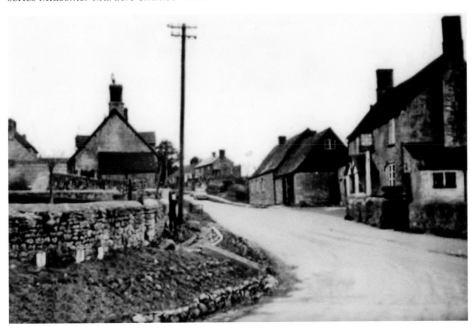

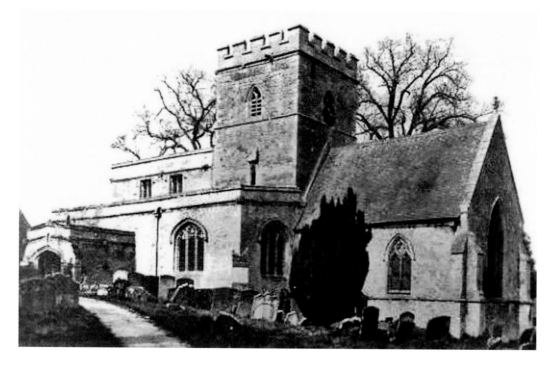

Beckley Church

The church of the Assumption of the Blessed Virgin Mary incorporates some Transitional Norman fabric, although the present building dates mainly from the Decorated period. It consists of a short nave flanked by north and south aisles, together with a central tower, chancel and south porch. The building was remodelled in the fifteenth century, when the clerestory was added above the nave. The sepia postcard view probably dates from the 1930s, while the colour photograph was taken in May 2013.

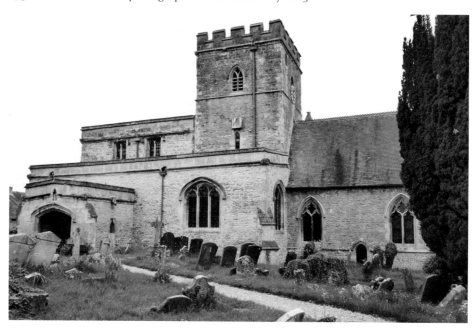

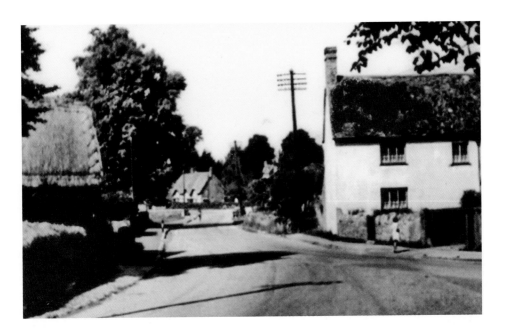

Cumnor: Old Houses in the High Street

Cumnor, about 2½ miles to the south-east of Oxford, was transferred from Berkshire to Oxfordshire in 1974. The village retains a pleasant, rural atmosphere, as exemplified by this *c.* 1930 postcard, which is looking westwards along the High Street. The colour photograph, taken in May 2013, provides a more detailed view of No. 2 High Street, known as Manor Farmhouse – an L-shaped structure dating from the eighteenth century that probably contains remnants of a much earlier building.

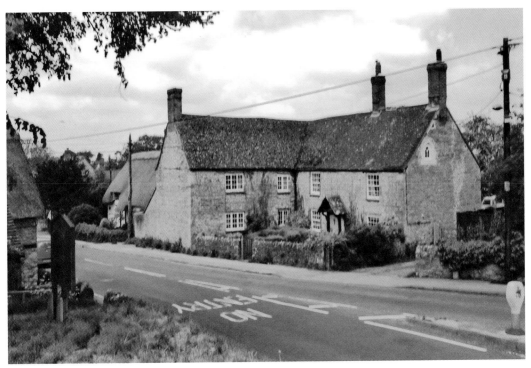

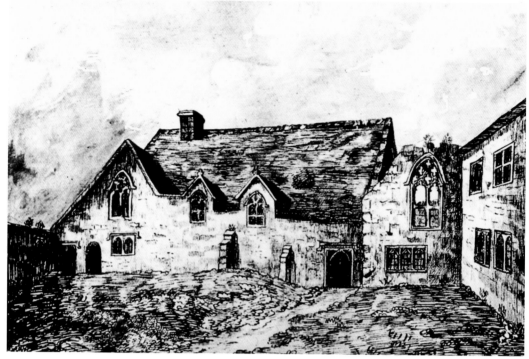

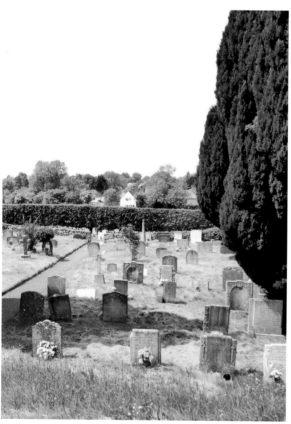

Amy Robsart & Cumnor Place

Cumnor will always be associated with Amy Robsart, who moved to the village in 1559 and was found dead on 8 September 1560, having apparently fallen down the main stairway in Cumnor Place. The Berkshire Coroner decided that she had died *per infortunam* (by misfortune), but malicious rumours persisted to the effect that she had been murdered by her husband Robert Dudley, the favourite of Elizabeth I, so that he would be free to marry the Queen.

The upper view is a Victorian sketch of *c.* 1850, which must have been copied from an earlier print, because Cumnor Place was demolished in 1811. This medieval building had formerly belonged to the Abbot of Abingdon, but at the time of the tragedy the property was leased to Anthony Foster, who later became Keeper of Dudley's Wardrobe. The site of the mansion, immediately to the west of the church, is now occupied by an extension of the graveyard, as shown left.

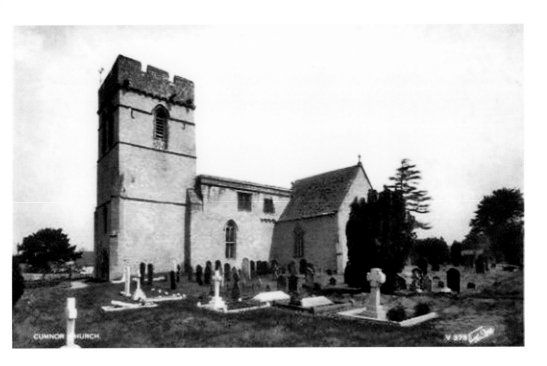

Cumnor Church

St Michael's church, originally Transitional Norman, was rebuilt in the thirteenth and fourteenth centuries. In its present form, the building consists of a nave, north aisle, chancel and north porch, together with a transeptal chapel on the south side. The sepia view shows the church from the south-west, while the colour photograph was taken from the south-east in 2013. The south transept, which was added during the early fourteenth century, gives the exterior of the building a slightly unbalanced appearance.

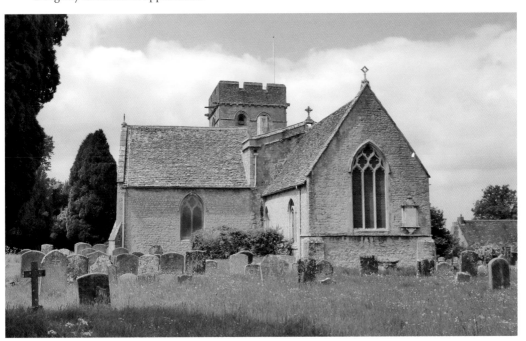

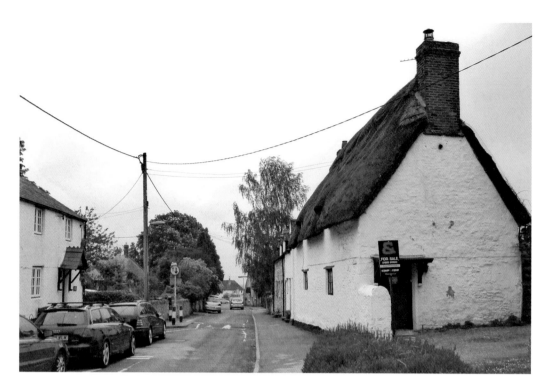

Forest Hill: The Main Street

Like Beckley, Forest Hill is a hilltop village in well-wooded surroundings to the east of Oxford. The sepia postcard view shows part of Main Street, probably around 1912, while the colour photograph was taken from approximately the same position in May 2013. A number of properties have been demolished, but Merrick Cottage, which can be seen on the extreme right of the old view, is still extant. It is of stone construction with a thatched roof, and dates from the seventeenth century.

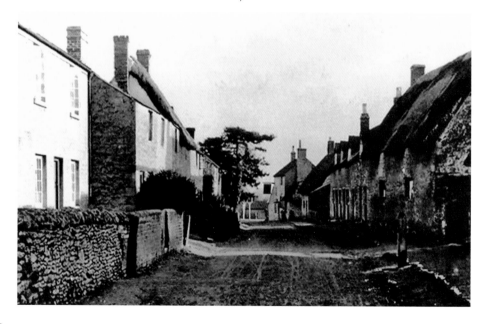

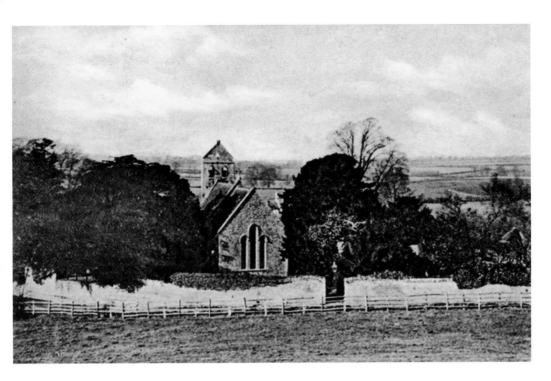

Forest Hill: The Church of St Nicholas

Dating mainly from *c.* 1200, the parish church consists of a nave, chancel and south porch, together with a Victorian north aisle that was added by G. E. Street in 1852. The west wall boasts a double bell-cote, and in 1639 two massive buttresses were built to support it. The lower view is a distant view from an adjacent field, whereas the recent photograph, taken in 2013, shows the heavily-buttressed west end of the building. John Milton was married to Mary Powell in this church in June 1642.

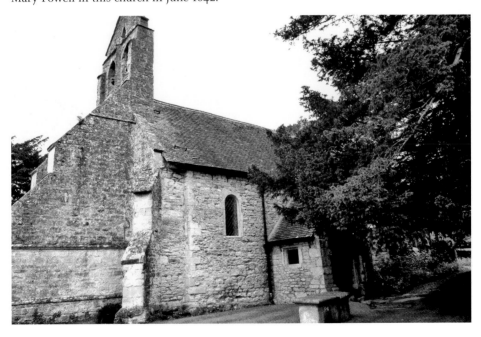

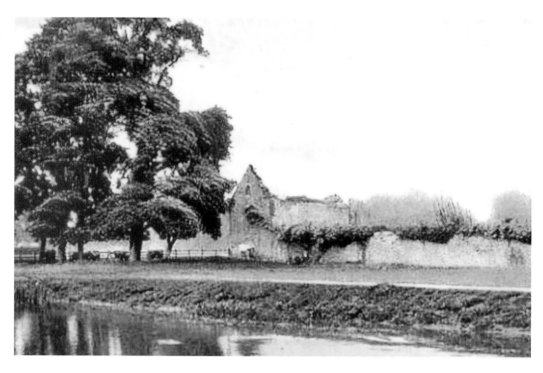

Godstow Nunnery & Fair Rosamund

Godstow, on the west bank of the Thames, about 4 miles north-north-east of central Oxford, is famous in connection with Rosamund Clifford (*c.* 1140–76), a mistress of Henry II, who was buried in a magnificent tomb near the High Altar of Godstow following her death at the age of around thirty-five. The nunnery became a private house after the Reformation, but most of it was destroyed during the Civil War. The upper view shows the ruined nunnery around 1910, while the colour photograph below was taken in 2013.

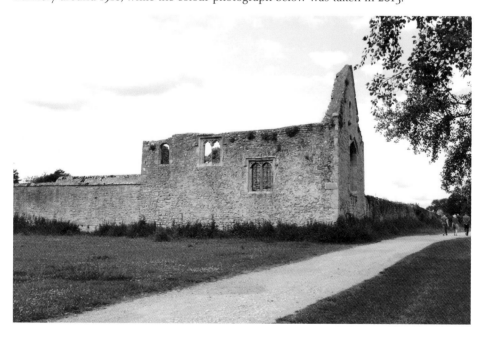

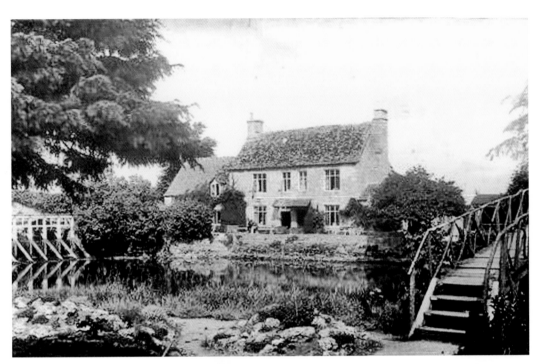

The Trout Inn, Godstow

The Trout Inn is said to have originated as an outbuilding of the nearby nunnery, although the present building dates mainly from the seventeenth century. In recent years, this famous riverside pub has featured prominently in Colin Dexter's 'Inspector Morse' novels and, as such, has appeared in several episodes of the popular television series. The sepia postcard probably dates from around 1925, whereas the colour picture was taken in 2013.

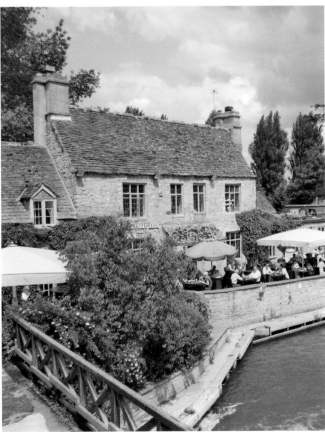

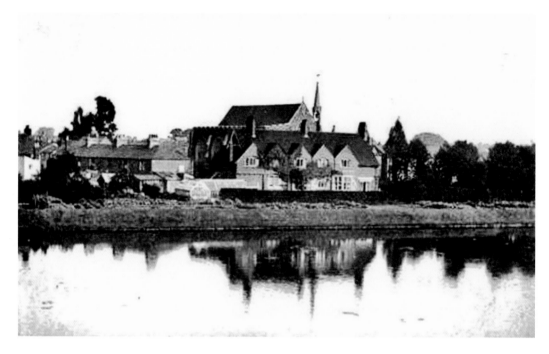

New Hinksey Vicarage & Church

Hinksey, formerly in Berkshire, consists of the villages of North Hinksey and South Hinksey, plus the Victorian suburb of New Hinksey. The upper view is an Edwardian postcard showing New Hinksey Vicarage and church, and the colour photograph was taken from a similar position in 2013. The expanse of water that can be seen in the foreground is a former ballast pit that was excavated during the construction of the railway; it later became a reservoir, and is now known as Hinksey Lake.

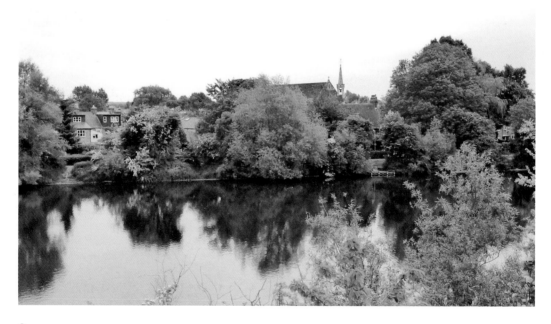

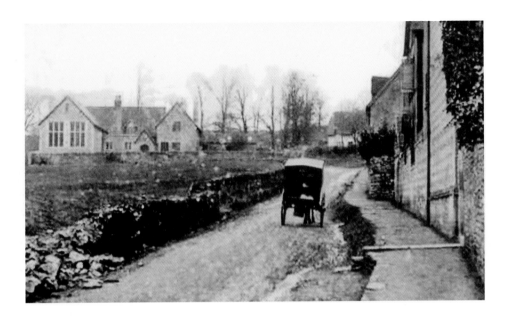

Horspath: Church Road

Horspath, just 1 mile to the east of Oxford's Eastern Bypass, is only a short distance from the industrial environs of Cowley. The 1932 edition of F. G. Brabant's *The Little Guide to Oxfordshire* warned that the village was 'fast becoming suburban', but in the event Horspath has remained a traditional rural village. The upper photograph is looking north-eastwards along Church Road towards the village school around 1920, while the colour photograph was taken from a position slightly further to the south in 2013. *Inset:* A detailed view of Horspath school, *c.* 1912.

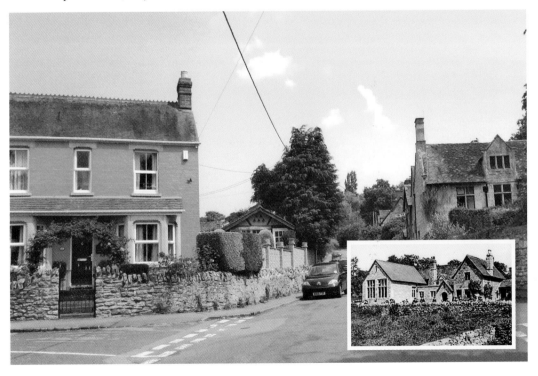

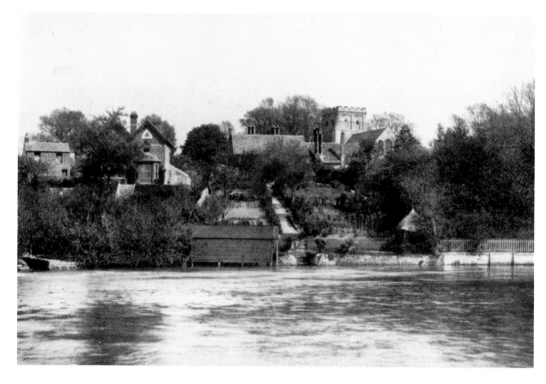

Iffley from the River

Although it is now part of Oxford, Iffley has, like Horspath, retained an idyllic rural character. The ancient village is situated upon a low hillock beside the River Thames, around 2 miles to the south of Oxford city centre. The upper view shows Iffley church and rectory from the river, *c.* 1912, while the recent picture provides a detailed glimpse of Iffley Lock. Dating from around 1630, this was one of the first pound locks on the Thames, although the present lock was built in 1924.

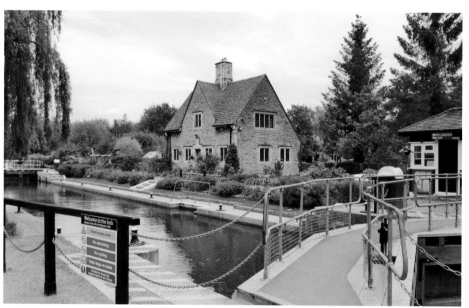

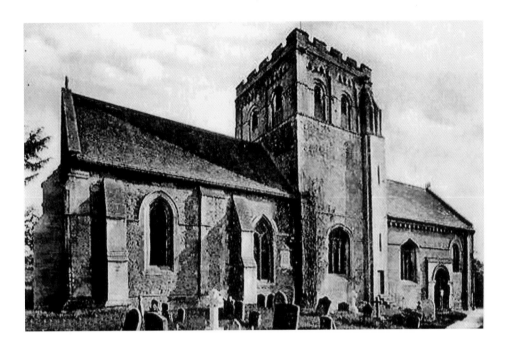

Iffley: St Mary's Church

Iffley parish church is generally considered to be one of the finest Norman churches in England. It was probably built between 1170 and 1180, and retains its original 'axial' plan, with an aisle-less nave and chancel separated by a central tower. The upper view shows this interesting old church from the north, probably around 1912; the chancel is to the left, while the nave is to the right of the picture. The colour photograph, taken in June 2013, shows the south side of the building.

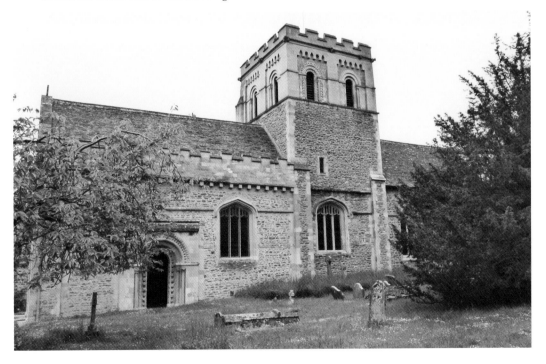

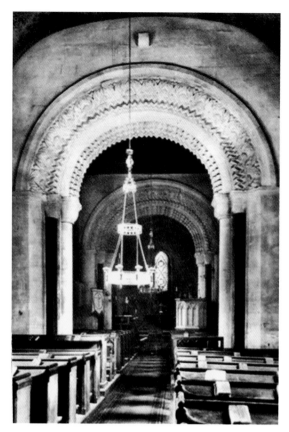

Iffley: The Church & Village

Left: This Edwardian postcard depicts the interior of St Mary's church, looking eastwards through the magnificently decorated Norman tower arches towards the chancel. The eastern bay of the chancel was rebuilt during the thirteenth century and some of the windows are later additions, but, otherwise, the church is a near-perfect example of late-Norman architecture, with a wealth of beakheads, chevrons and other carvings. *Below*: A recent view, showing old buildings in Church Way. No. 122, to the left of the picture, was originally known as Court House, while the thatched building to the right is a former barn, which was adapted for use a Parochial School in 1838. In the meantime, a separate school had been established with the aid of a bequest from Sarah Nowell, and in 1853 the two schools were amalgamated. The school was closed in 1961, and the building has now found a new role as the church hall.

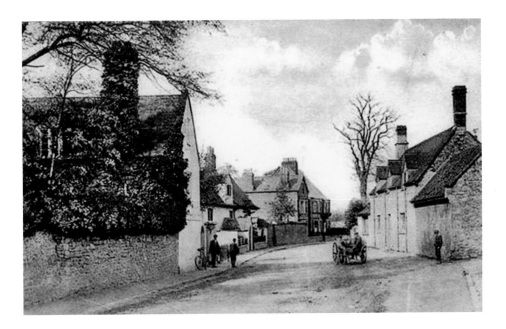

Iffley: Old Buildings in Church Way

Iffley's main street, known as Church Way, winds through the village from Iffley Turn to the famous church. These contrasting views are looking northwards along Church Way during the early years of the twentieth century, and in June 2013. No. 92, Rivermead, which can be seen in the centre of the sepia view, has an unusual gabled porch. Interestingly, some of these old houses have wells in their cellars, Church Way being built above a network of springs and streams.

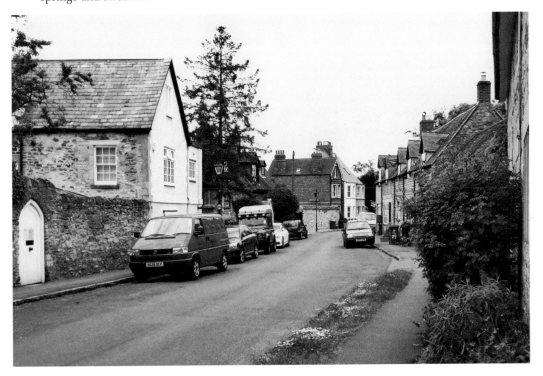

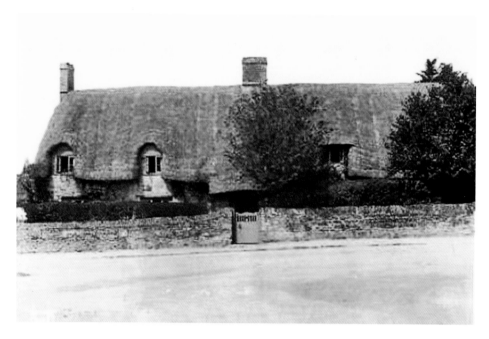

Iffley: Mill Lane

Situated at the corner of Church Way and Mill Lane, No. 2 Mill Lane is a picturesque old thatched property that was probably built during the early seventeenth century. The upper view dates from the early years of the twentieth century, whereas the colour photograph was taken in June 2013.

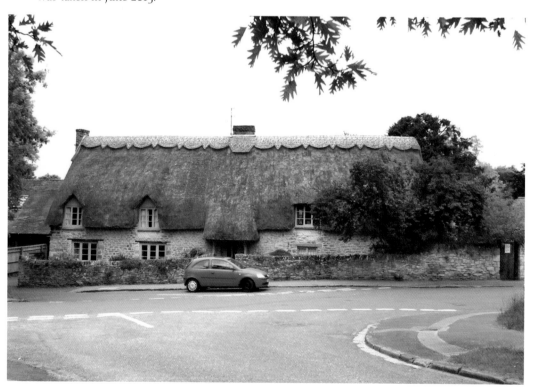

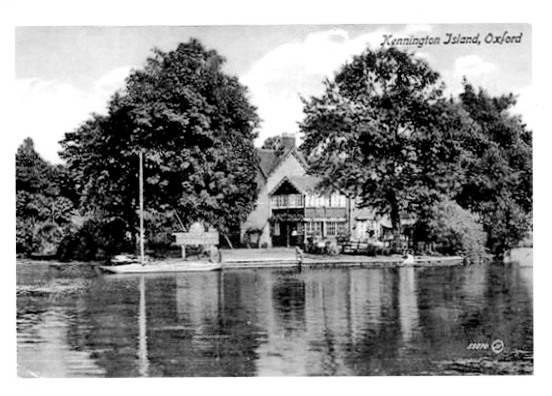

The Tandem Inn, Kennington

Two Edwardian postcard views of Kennington which, like Iffley, has been absorbed into Oxford. The upper picture shows the River Thames at Kennington Island, while the old thatched building depicted in the lower view is a pub in Kennington Road that was, at one time, known as The Fish, although it was renamed The Tandem around 1915. This popular riverside pub still exists, but the present-day Tandem is very different, the building having been extensively rebuilt.

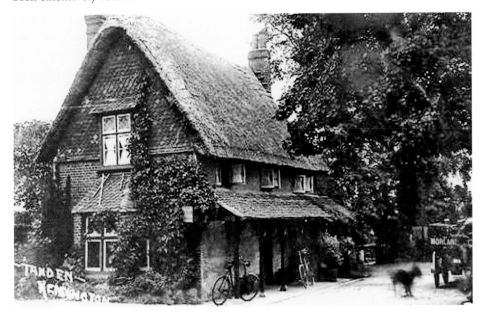

Wolvercote Canal Junction

Wolvercote, about 4 miles to the north of Oxford town centre, and now joined to the city by ribbon development, is both a canal junction and a railway junction. The upper picture shows the canal junction in 2013, while the lower view provides a glimpse of the narrowboat *Pearl* moored at the same location around 1967. It is believed that *Pearl* was built at Braunston as an unpowered 'butty' for Thomas Claytons Ltd in 1935, and rebuilt as a motor boat in 1945.

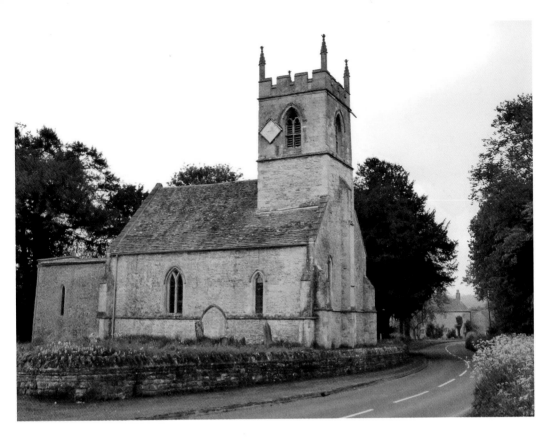

Holy Rood Church, Woodeaton

The tiny, Cotswold-style village of Woodeaton is situated some 6 miles to the north-east of Oxford. Holy Rood church, which dates mainly from the thirteenth century, consists of a nave, chancel and tower, the tower being a later addition that is supported upon massive piers at the west end of the nave. The upper view shows the church in 2013, while the sepia postcard provides a glimpse of the Old Rectory, probably around 1930.

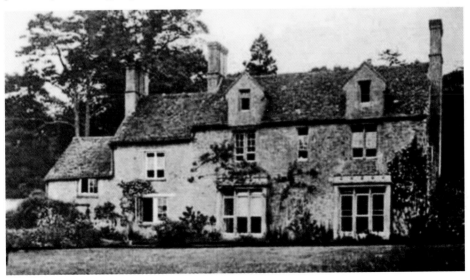

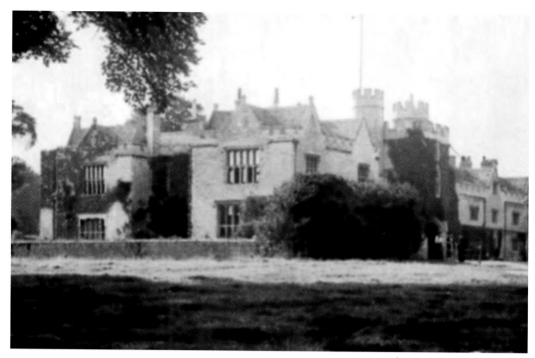

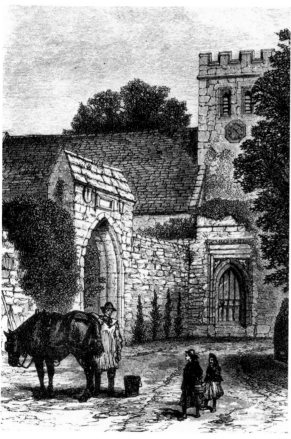

Wytham Abbey & All Saints Church

Wytham is another Cotswold-style village, with stone-built houses and cottages. It nestles beneath the magnificently-wooded Wytham Hills, and is only a short distance from the River Thames. Prior to local government reorganisation in 1974, it had been the most northerly village in Berkshire, but it is now part of Oxfordshire.

The upper picture shows the manor house, which is known as Wytham Abbey, although there is no evidence that it was ever used as an abbey or religious house. The building, once the seat of the Earls of Abingdon, has now been divided up into private apartments. The lower illustration shows All Saints church, a fourteenth- and fifteenth-century building that was rebuilt around 1812, using architectural fragments from Amy Robsart's house at Cumnor (*see page 76*). The medieval gateways that can be seen in the picture were both taken from Cumnor Place; the one on the left is dated 1372.

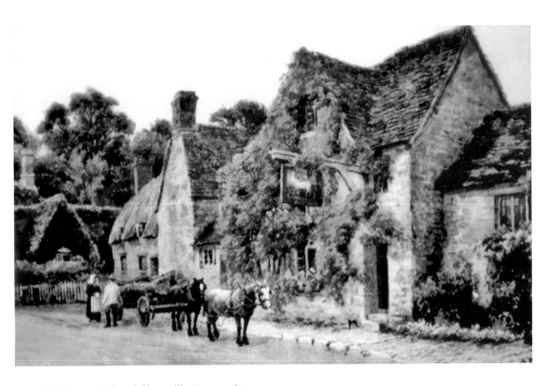

Wytham: Colonel ffennell's Generosity

In 1920, the Wytham estate was purchased by the philanthropist Colonel Raymond ffennell (1871–1944), who allowed Wytham Woods to be used for educational purposes by inner-city children. Prior to his death, Colonel ffennell made arrangements for the 3,108 acre estate to be transferred to Oxford University by gift, sale and bequest, the conditions upon which the sale and gift were made being designed to preserve the character of the estate in perpetuity. The accompanying pictures show the village pub around 1906, and in 2013.

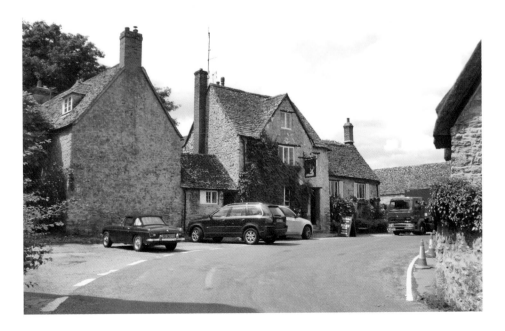

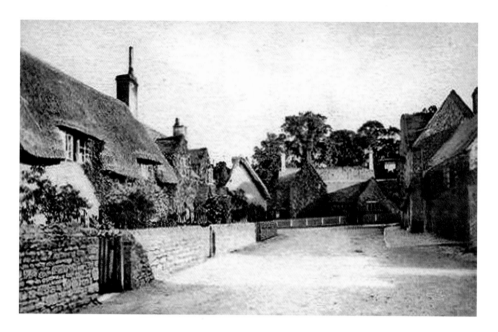

Wytham: The Village Street

These 'then and now' views are both looking westwards along the main street. The upper photograph dates from the early years of the twentieth century, and the recent view, which shows two of the old cottages in greater detail, was taken in June 2013. Writing in 1911, Frederick Brabant said that Wytham was 'highly-picturesque, consisting of well-built stone cottages lying amongst well-kept garden, where strawberries are largely grown'. He added that, at the end of June, 'all Oxford comes here to eat strawberries'.

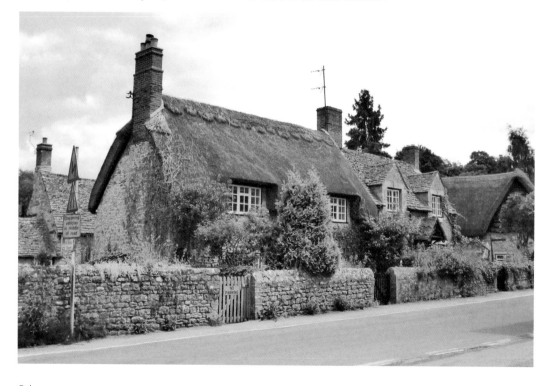

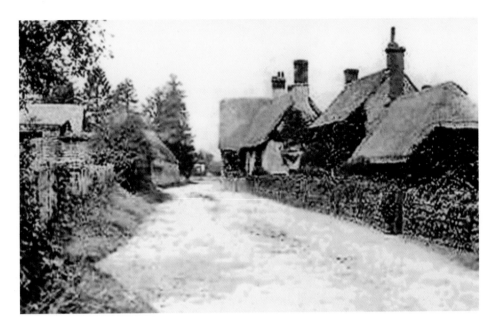

Wytham: Old Cottages in Botley Road

The two photographs show traditional stone cottages in Botley Road, the upper view dating from around 1913, while the lower view was taken a century later in June 2013. The cottage in the foreground has clearly been modernised, but the neighbouring L-shaped house appears to be in more or less its original condition.

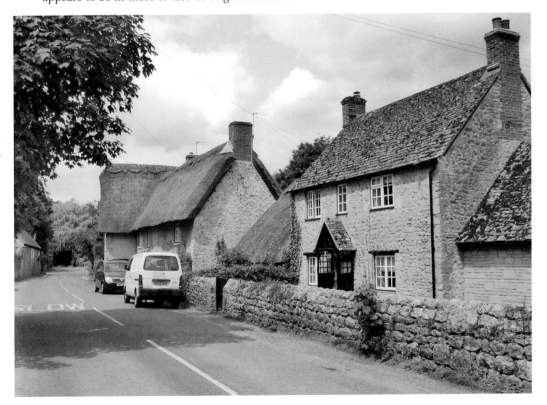

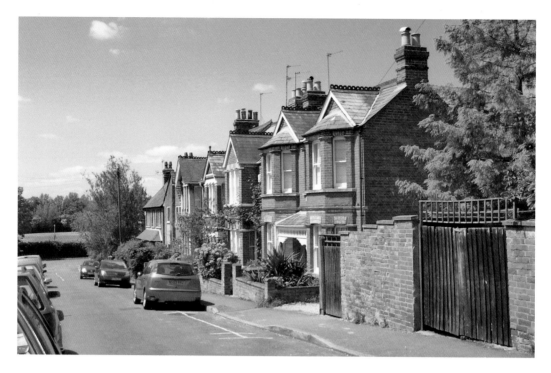

Around Oxford: Envoi

Two final views of Oxford villages and suburbs in the summer of 2013. The upper picture shows the lower end of Bedford Street, with Thames-side meadows visible just beyond the Victorian terraced houses. The lower view depicts part of St Andrew's Road in Old Headington. The houses that can be seen in the picture are clearly of no great antiquity but, with the church in the background, they form part of a pleasant village scene.

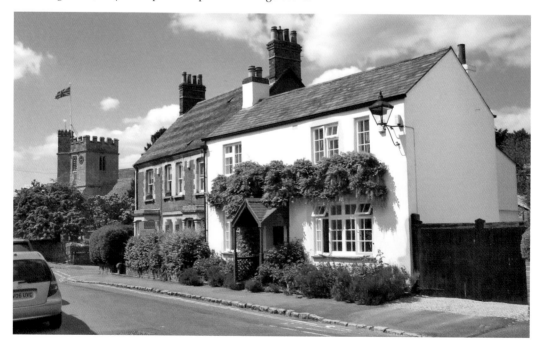